S0-BGS-039

We

Were

Three

The Travel Albums of
George Platt Lynes, Monroe Wheeler,
and Glenway Wescott
1925–1935

Texts by

Anatole Pohorilenko

and

James Crump

TR
790
P6
T8
1998

ARENA EDITIONS

$ 65.00

CALIFORNIA INSTITUTE OF THE ARTS

AAZ-4547

When

Contents

The Expatriate Years, 1925–1934

"This is a milestone date in our lives: this afternoon Monroe received a letter from George to say he is leaving us," wrote Glenway Wescott to his brother Lloyd and sister-in-law Barbara on February 26, 1943. Written by a man in pain who feared for both Monroe and George, Glenway's letter gently brought to a formal close the remarkable and complex triangular relationship that had lasted for sixteen years. From the moment these three appealing and talented men came together, their physical attraction and profound love for each other served as a stimulus to their senses and nourished their gifts and, in the process, enriched their own lives as well as ours. The history of American literature and of museum and photographic arts would have been somewhat different today had Monroe Wheeler, Glenway Wescott, and George Platt Lynes not met and fallen in love.

Monroe Lathrop Wheeler was born in Chicago, Illinois, on February 13, 1899, to a household that consisted of his father, Fred Monroe Wheeler, then twenty-six and a Chicago fish broker; his mother, Ana Kienzle Wheeler (plates 121, 122), a twenty-three-year-old of German descent; and a four-year-old sister, Doris. Of English stock, the Wheeler's American roots were established first in Davidsburg, Michigan. In 1901 the family moved to Evanston, a suburb of Chicago, where sister Helen was born in 1907 and brother Richard in 1913. Helen died during an appendectomy when she was ten years old. All evidence suggests that the Wheelers were a good middle-class family whose idealism and enthusiasm for the arts were strongly tempered by their love of God and their country and by their own particular

sense of social restraint and respect for tradition. Fred, to whom Monroe was much devoted, was a businessman who played golf, painted, and helped establish the Businessmen's Art Club of Chicago. He was quite a skillful artist, judging from the sensitive and sentimental etchings he made directly from the postcards Monroe would send him later from abroad. Fred was also a bibliophile who collected books and made bookbindings. In a famous photograph taken of Monroe in 1983 for *Connoisseur* magazine, Monroe is shown in his New York City apartment, next to his beloved gothic bookcase, holding his father's beautifully bound copy of Longfellow's *The Song of Hiawatha*.

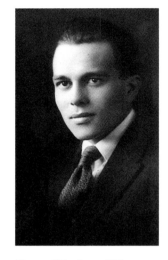

Monroe Wheeler, c. 1918.

During Monroe's growing-up years it was not unusual for the family to attend Chicago Symphony concerts, the opera, poetry readings, and song recitals. Glenway once recalled that during a 1930 rehearsal of the *St. Matthew's Passion* in Chicago, Monroe wept during the passages "See Him," "Who," and "The Son of God." Throughout his life Monroe remained fond of German classical music, particularly that of Beethoven, Mozart, and Gluck. He once said that he wanted the adagio movement of Beethoven's "Emperor" Concerto and Gluck's "Dance of the Blithe Spirits" played at his funeral service.

Monroe first became aware of his homosexuality during a visit to a Chicago museum where he literally "fell in love" with a Greek male nude statue from antiquity which, according to him, "was so beautiful that it made me swoon. It was the image that would excite me when I masturbated. After a while I realized that it was an indication of my homosexuality, though I often preferred the social company of women." However, these sexual feelings had to be hidden, repressed. By deliberately cultivating a masculine demeanor both in dress and mannerisms, he participated in a heterosexual social world without affronting or intimidating males and one in

which females were his close friends and backers. His homosexuality was never an issue with him or with his family, even when his relationship with Glenway became quite obvious to everyone.

Despite his love of books, Monroe was never regarded as an outstanding student, and after completing his secondary education, it is not clear if he ever went to college. He never spoke of it, perhaps regretting not having done it. His extraordinary curiosity, however, made him a lifelong student of fact and of human nature and its expression. Wheeler believed this curiosity contributed to his longevity and he maintained that people did not die of old age but of boredom. He gauged his own personal growth against his favorite pictures whose effects on him were both medical and inspirational, a practice that lasted well into his eighties when the stimulation of a visit to a museum would dull the pain in his arthritic spine and provide the energy to outwalk a companion forty-four years his junior. Monroe was interested in facts, social gossip, anecdotes, and memorable turns of phrases. He delighted in the realization that most snippets and expressions occurred spontaneously, unexpectedly, and by accident, and this led him to jot down on whatever he could find in his coat pockets — a little blue or black spiral notebook, an envelope, a napkin, or a matchbook cover — brilliant repartee of dinner table conversations and telephone calls. He would later transcribe this impressive information into his commonplace book. He preferred stories that had a hidden meaning, usually a good-natured slap at what he considered to be exaggerated, phoney, or untrue. He was a listener by nature and a talker by profession, and he discovered in himself a gift for wit and anecdote — tools for teaching and illustrating. Janet Flanner, a close friend he met in the early 1930s, said this of Monroe: "[He] has an excellent raconteur's mind, memory, vocabulary and tongue, brings in a story just at the right time, in the right manner, serves his anecdotes perfectly either piping hot or ice-cold as tragedies. . . . The bases of his success with people are the nourishing quality of his enthusiasms and his connected recollections in conversation." Indeed, he used to say: "Connect, connect, connect."

On his eighteenth birthday, Monroe asked his father for a motorcycle. Instead, he got a small Gordon printing press. He did not know what to do with it until a friend said to him, "But, you know, you can make money printing." That had never occurred to Monroe. Shortly thereafter he received orders from his father and his father's associates, and soon the two friends were printing thousands of shipping tags. This led to jobs in promotion and advertising and to a thorough knowledge of typography, layout, reproduction techniques, and fine art printing. Monroe was to establish one of the finest small edition presses of the century and, later, under his direction at the Museum of Modern Art, his standards came to be the highest in art book production anywhere.

Monroe's love of and belief in the power of the word and image as well as in the emotional effects of music he had absorbed during his adolescence eventually led to an extraordinary appreciation, or even worship, of those who were artists, writers, or musicians. In his life, books and artworks were second only to people who endeavored and succeeded in these arts. One of his regrets, he once confessed, was not having been born with a specific talent, forcing him to remain, throughout his life, an admirer, a passive amateur in the truest sense of this word. His respect and admiration for natural talent had a profound effect

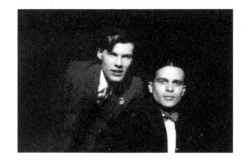

Glenway Wescott and Monroe Wheeler, c. 1919.

upon him throughout his life, often determining sexual liaisons and lifelong relationships, particularly when such talents appeared in combination with someone who was young, attractive, and idealistic, for he loved to shape it and be part of its development. And even when the initial physical attraction faded, he would, in nearly all known instances, remain loyal and caring toward that individual.

In 1919, when he first met Glenway Wescott, still in his teens and president of the Poetry Club of the University of Chicago, Monroe was twenty years old and

at the height of his romantic good looks. Always impeccably dressed—he even wore a jacket and tie to the grocer's—he carried himself with gentlemanly tact and a shy nobility that exuded patience and hinted at asceticism. However, monkish he was not. When not wearing a hat, his hair was slicked back with pomade. His high forehead, bright, nearly black eyes—once described as "sparkling like camera lenses"—and his full, sensuous lips, and strong, prominent jaw, together with his olive skin tone, betrayed a certain air of Mediterranean inquisitiveness which, at any moment, could dissolve into an ironic grin or an idiosyncratic chuckle that, in itself, made a statement. He spoke sparingly, but when he did, his speech was marked by a midwestern cadence, reflecting his adolescent roots. Above all he was a listener whose way of listening to and of looking at the speaker invited him or her to elaborate, making him or her believe that what they were saying was important and memorable. This served him well in the voluble art and literary worlds he frequented throughout his life. Even after a stroke two days after Glenway's death on February 20, 1987, which left Monroe legally blind and paralyzed on the left side of his body, this quiet but intense five-foot-eight-inch-tall observer was seen at the Museum of Modern Art, in a wheelchair, looking quite erect and greeting numerous friends at a Paul Klee retrospective. As he was wheeled from picture to picture enjoying the spontaneous whimsy and humor of Klee's art, an observing Saul Steinberg exclaimed, "What a centaur!" This is the man with whom Glenway Wescott had fallen in love.

Glenway Gordon Wescott is vaguely remembered today as an American expatriate writer—contemporary with F. Scott Fitzgerald, Ernest Hemingway, and Gertrude Stein—whose literary and social activity placed him in Paris, the French Riviera, and New York between the great wars. To those familiar with his work, he is known as one of the major novelists of his generation. He was only twenty-six when he won literary acclaim and the Harper Prize Novel Contest with *The Grandmothers* (1927), a book critic Bruce Bawer described in 1987 as marked by a style that included

"sensitively drawn characters; a witty and perceptive eye for detail; a prose of wonderful, almost Flaubertian, control, elegance, and penetration; and above all, a rare delicacy and honesty of feeling — but feeling that has been digested, disciplined, transfigured into art." Whether in verse or in prose, nowhere are these observations more elegantly presented than in *The Pilgrim Hawk* (1940), "a nearly perfect work — taut, subtle, and exquisitely ordered," in which he explored the human condition as it applied to himself and those around him, in matters of love, homosexuality, marriage, loss of affection, impotence, and death. Essentially self-taught, Glenway Wescott turned his literary talent into a relentless and lifelong search of himself as a homosexual with the vain hope that it would yield a better and more intimate understanding of his mid-

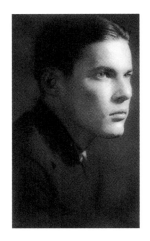

Glenway Wescott, c. 1924.

western landscape, family members, lovers, and friends. He believed that such an endeavor could provide not only the necessary answers but explain to others, in an intuitive and nonscientific way, his own worthiness and humanity. His subjects, whether landscape or people, "each one a life," he said, "extended into the past like a corridor — poorly lighted, long corridors winding away in every direction, through reticence and forgetfulness, to their youths; and the ring of rocking chairs, the child [himself] for whose existence all corridors had come together, had shivered in the gusts of emotion which blew vaguely down them, and tried to understand the strange syllables which echoed from one life to another." In the late forties, after *The Pilgrim Hawk* (1940) and *Apartment in Athens* (1945), Glenway Wescott was elected to the presidency of The American Academy and Institute of Arts and Letters by his own fellow writers.

The oldest of five children, Glenway was born on a humble pig farm near Kewaskum, Wisconsin, on April 11, 1901, to Bruce and Josephine Gordon Wescott (plate 133). Although lacking obvious effeminate traits, Glenway grew up as a sensitive child in a no-nonsense, hardworking family, often running afoul of his

father's expectations. He escaped this difficult circumstance by living with his uncle's family, as well as others. In a short story Glenway published years later, "The Babe's Bed" (1922), he described one of many confrontations he'd had with his father, who "had provoked him; then, too, there had been talk of youngsters' deserving to be driven from home, or whether or not a father was master in his own house.... Unhesitatingly he [Glenway] had replied, the most logically insulting phrase after phrase. He remembered vividly how he had been: slight and pallid, detestably afraid, fighting back in barking tones like some animal instinctively inspired." At age thirteen, he submitted his first literary effort to a school paper, and entered a two-year relationship with a fifteen-year-old boy named Carl. At age sixteen, when he entered the University of Chicago, Glenway was very handsome in a rugged, masculine way, and he embodied the all-American look. Never trendy for he could not afford it, he was a creative and elegant dresser who carried himself taller than his full five-feet-eleven-inches. His stern full mouth, assertive chin, steely blue eyes, and wonderful shock of blond hair, which in Europe he wore slicked back and parted in the middle, gave him the look of an intelligent but not easily accessible beauty. Despite this concentrated, serious look, he made friends easily for he also had a radiant smile that was totally disarming.

"I had never written a poem until I got to the University of Chicago. I lived out in the West Side with my Uncle Will, and had fifty cents a day allowance." Except for the Poetry Club of which he became president, Glenway did not get much out of the University of Chicago, which he left after his third semester. The Poetry Club included such figures as Yvor Winters, Winters' future wife Janet Lewis, Pearl Andelson Sherwood, Kathleen Foster Campbell, Maurice Lesemann, Mark Turbyfill, all in their teens, and Elizabeth Madox Roberts, some twenty years older than the others. The poetry they all wrote and shared would later become known, primarily through the efforts of Winters, Lewis, Hilda Doolittle, and Mina Loy, as imagist. Encouragement to the members of the club was provided by the sustained generosity of Harriet Monroe, who often published their pieces in *Poetry*

magazine. She also invited club members to her home to meet distinguished literary visitors such as Vachel Lindsay, Carl Sandburg, and Edgar Lee Masters. Maurice Lesemann, considered by all to be the most promising poet of the group, was a perfectionist who never found his own poems adequately "finished" to publish as a book. But it was Elizabeth Madox Roberts, older and often in frail health, who was the club's central figure who a dozen years later dedicated her 1930 masterwork, *The Great Meadow*, to Glenway (plate 123). As the club's president and driving force, Glenway encouraged members to share their poetry: "We were continually reading our poetry to each other." When jobs or illness took club members away from Chicago, they exchanged poems and ideas by mail. Roberts' correspondence with Glenway, Winters, and Lewis continued, if at times sporadically, until her death at age sixty in 1941.

It was in the spring of 1919 at a meeting of the Poetry Club that twenty-year-old Monroe and not-yet-eighteeen Glenway met and fell in love. Thus began an extraordinary relationship between two men who, despite their tender years, overcame many personal and social challenges, even an eventual lack of sexual interest. Based on intellect, love, and mutual respect, together they created a life that lasted for sixty-eight years. Of those heady early days a more emotional Glenway recalled Monroe, bearing arm loads of red roses, visiting him in a hospital where he was recovering from the deadly Spanish flu. A more fact-oriented Monroe noted in his engagement book, Wafer, as he referred to it, the number of times he and Glenway had made love in the past week. Never mind that he had recovered from the deadly virus and quit the university at the end of that term; the focus of Glenway's life was Monroe.

After quitting the university, the prospect of Glenway returning to his farm country 120 miles north was unthinkable. A job as a store clerk turned out to be a three-week disaster. Despite their meager finances, both he and Monroe, who was writing advertising copy and living at home, managed to visit museums and attend lectures and concerts. They saw each other four times a week on the average, often as dinner

or lecture guests, in the company of others, especially the members of the Poetry Club with whom Glenway stayed in touch, particularly with Yvor Winters who had in 1918 gone to Santa Fe, New Mexico, to treat his tuberculosis. In addition to their visits, Glenway and Monroe corresponded with each other; exchanged treasured books found in secondhand bookshops with tender dedications and reminders of special events or moments in their relationship; and compiled into notebooks remarkable quotes, wisdom, and edifying thoughts, as well as well-written paragraphs written by thinkers whose works and words withstood the accidents of history. They used words with great care and respect; whether spoken or written, expression meant everything.

In the fall of 1919, Glenway presented Monroe with a gift of seven short poems, some of them clearly addressing the mixed defiance and fear of a young male couple in a hostile society.

Black Art

You did not know how brave you were.
And I, like a starving wolf,
Followed the shadow of your fire,
Sorted your secrets from the dust
To satisfy my hunger.

You did not know,
I was a coward . . .
Now we can shift the skies.
We can endure
The hoof-beats of the wind upon our heads.
Why, we would dare to climb
Out of a withering world
Into a new star!

But let us laugh carelessly like other men.

Let us be timid, even among fools.

Let us knot silence round our throats.

For they would surely kill us.

In early 1920, Winters, now in residence at the Sunmount Sanatorium, convinced his father to finance Glenway's trip to Santa Fe, where he hungered for literary conversation and intelligent companionship. Through Winters and Alice Corbin Henderson, another Chicagoan also in Santa Fe for a tuberculosis cure, Glenway made the acquaintance of the modernist painter Marsden Hartley. In Hartley's paintings Glenway saw his own mystical fascination with the New Mexico landscape:

> Down the valley of broken mountains
> Death walks slowly,
> Slowly on the silver feet of echoes.
>
> (Sanatorium, February 14, 1920)

> Mountains which float in the green swirls
> Of twilight as petals . . .
>
> (O God, the Night Is Vain, February 14, 1920)

While Glenway was in Santa Fe, Lesemann went to New Mexico to visit him and Winters, and stayed to teach at Cerrillos, not far from where Winters taught a small class. Monroe also went to visit, taking with him a photographic camera borrowed from Janet Lewis. In 1922, Janet Lewis, after being diagnosed with a light case of tuberculosis, arrived at the Sunmount Sanatorium and, a year later, Lewis and Winters fell in love and married. Later they moved to Palo Alto, California, where they founded a mimeographed quarterly magazine, *GYROSCOPE*, which is remembered

for the important early works contributed by Winters, Lewis, Allen Tate, Hart Crane, and Katherine Anne Porter. The Winters' friendship with Glenway endured for the rest of their lives.

Glenway left Santa Fe in the fall of 1920. After a visit to his family in Wisconsin, he and Monroe lived together first in Evanston and then moved to a boardinghouse in downtown Chicago. It was when they were in Evanston that Monroe suggested a solution to the social prejudice Glenway feared and expressed in the poem, "Black Art": Society would overlook their homosexuality if he became

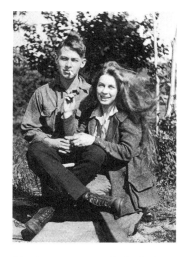

Maurice Lesemann and Elizabeth Cosse Dempster, 1920.

a famous poet; they would "leave him alone," he specifically said. Thus in late 1920, using the little savings he had, Monroe published the first in a series of beautifully conceived chapbooks, *The Bitterns*, which featured twelve poems by Glenway and was dedicated to their friend and fellow poet Arthur Yvor Winters. This limited edition of two hundred small booklets was bound in a velvet-black paper cover that bore a silver foil-stamped design by Fredrick Nyquist, and its pages were bound together by a black silk braid. It was their maiden publication and it was well received. Wallace Stevens wrote to Glenway: "It is difficult to make poetry as sophisticated as this fly. But you certainly make it tremble and shake. I shall watch your work with the greatest interest."

Despite job instability and a chronic lack of money, the young lovers' discipline and ambition led them to extraordinary adventures and considerable accomplishments. In the spring of 1921, Miss Monroe, the editor of *Poetry* magazine, employed Glenway as an office boy, while Monroe continued to write advertising copy for various businesses, including Miss Monroe's food store, the Petit Gourmet. That

summer, Mrs. William Vaughn Moody, a Chicago literary hostess and widow of the playwright, took Glenway under her wing. She actively promoted him and even sent Glenway and Monroe to stay at her Berkshires property in West Cummington, Massachusetts, a place where Glenway turned out to be "a marvelous cook." There they experienced "the gorgeous and unrestrained coloring of the leaves." In September *Poetry* came out with *Still Hunt,* a grouping of six new Glenway Wescott poems. One of them, "The Poet at Nightfall," revealed a secret but platonic relationship Glenway had had around 1918 with a fellow poet of the Poetry Club, Kathleen Foster. That fall, Monroe published Yvor Winters' small volume of poetry, *The Immobile Wind,* along with Mark Turbyfill's much longer *The Living Frieze.* In the December 1918 issue of *The Dial,* Glenway presented "Natives of Rock," a remarkable poem that would be republished several times over the years. In 1925, this poem, together with several others, was brought out again in an illustrated publication by Francisco Bianco in Chicago with an introduction by Glenway and a dedication to Bernardine Szold (plate 9). Many years later, upon Monroe's first exhibition for the Museum of Modern Art, he had Ignatz Wiemeler make a deluxe leather binding for copy number 306. It is from this volume that Hugh Ford read "Evening Illusion," "Mountain II: The Hallucination," and "The Beginning of June" while a portion of Monroe's ashes were sprinkled where Glenway's had been scattered earlier. This book of twenty poems bears the following inscription in Glenway's hand: "For Monroe, with whom I wrote these verses in Evanston, in West Cummington, in Wiesbaden and Bonn — Merry Christmas and Happy New Year, 1948–1949."

It was a widely held notion at the time, certainly shared by both Glenway and Monroe, that in order to be inspired and well known, a poet had to travel. With a favorable rate of exchange, Mrs. Moody's financial assistance, and letters of introduction provided by Harriet Monroe, the lovers embarked on a journey in the latter part of October that took them to London, Wiesbaden, and Bonn. In London, they met Sir and Lady Laverty, who introduced them to R. B. Cunningham Graham, and other writers such as Raymond Mortimer, Osbert Sitwell, and Ford Madox Ford. Ford in particular befriended Glenway, and he recommended the expatriate writer's

way of life. Mortimer, an art critic and great traveler, was to become one of Monroe's closest friends. He introduced Glenway to other friends such as Eardly Knollys and was his favorite traveling companion over the years. London not only dazzled the lovers with sociability; here they saw works of art they had seen only as black-and-white reproductions: Dürers, Holbeins, El Grecos, Velazquezes, and Goyas to name a few. England's high cost of living, its cold and humid winters, and its distracting beauty prompted Glenway and Monroe to move to the Continent where they spent an unforgettable German Christmas in Wiesbaden, an elegant German city full of

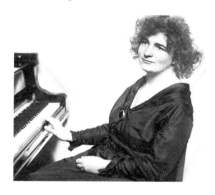

Elly Ney, 1922.

music and noted for its glorious landscape. It was an inspiring, peaceful setting most conducive to writing. In addition to preparing short travel pieces for newspapers back home, Monroe endeavored to publish his chapbooks in Germany for a "ridiculously low" cost and maintain his Evanston address on the publications. It was in Bonn, Beethoven's birth city, in the spring of 1922 that the men experienced the first great test of the strength of their relationship. The test was Elly Ney, a famous female pianist and interpreter of Monroe's favorite composer, Beethoven.

A tall, stately figure with a shock of dark hair that eventually turned white, Elly Ney was striking and memorable on the concert platform, the place where Glenway and Monroe first saw her when she was reading the Heiligenstadt Testament at a Beethoven recital. Elly had won the Mendelssohn Prize in 1900 and married the Dutch violinist and conductor Willem van Hoogstraten, by whom she had a daughter. In 1920 they divorced, and later, for a short time, she was married to Paul F. Allais of Chicago. Although she excelled in the music of Schumann, Chopin, Mendelssohn, Brahms, and Mozart, it was as an interpreter of Beethoven that she was most admired by her contemporaries. At a time when interpretations were more romantically conceived, her powerful technique was characterized as "eliciting tones

of luminous depths," and her Beethoven recitals were referred to as "incursions into the composer's timeless inner sanctum; [she has] the ability to establish a three-way spiritual communion among the composer, the audience, and herself." She was a legendary eccentric who believed in "electrifying" her audiences.

Although Monroe's infatuation with Elly was probably based on her musical powers and his pleasure in female sociability, it nearly ruined his relationship with Glenway. Monroe's affair with Ney turned out to be so traumatic and painful for Glenway that it led him to question his own ability to hold a lover and made him question his future and wonder about the possibility of living his life without Monroe. He decided if Monroe was to continue with Ney, he would return to Chicago and marry Kathleen Foster. Soon after, Monroe and Glenway agreed to continue together, but their loving relationship was forever altered. They decided to stay together with the understanding that if either one of them was attracted to someone else, he must know that such an attraction could ruin their relationship. It was at this time that they developed the lifelong habit of whistling a particular musical phrase, Mozart's "Pace, Pace," a peace offering and sign of conciliation for difficult moments. This type of accommodation became the basis of an ethical code of conduct that serviced their future personal relationships and was especially useful when such people as Jean Bourgoint, Barbara Harrison, Jacques Guérin, Eardly Knollys, and George Platt Lynes entered their lives. On September 20, 1922, both Glenway and Elly Ney sailed together to the United States, he to visit his family and prepare an apartment for himself and Monroe in New York City and she for a concert tour. Monroe remained in Germany to arrange for the publication of Maurine Smith's *The Keen Edge* and Janet Lewis' *Poems (The Little Indians in the Woods)*. Unsure of what address to assign these books, he chose Evanston even though they were printed in Germany.

Elly Ney stayed in Glenway's and Monroe's lives for many years, often visiting them on the French Riviera and in New York while on tour. After her miserable divorce from Allais, she returned to Germany and was "adopted" by the Third Reich because "her mystical approach to music combined German nationalism with

the destiny of German art." After World War II, during which she taught at the Salzburg Mozarteum, she was discredited and her later career was confined, for the most part, to small West German towns and to lesser record labels. She did make one postwar appearance at London's Royal Festival Hall but, perhaps influenced by her prewar repertoire, she was forced to play Tchaikovsky's First Piano Concerto. Elly Ney died in 1968.

The fall of 1922 found both Monroe and Glenway occupying a basement studio at Lexington and Eighteenth Street, living in severe poverty. Monroe was unemployed and looking for work, and Glenway returned to Germany as personal secretary to Henry Goldman, a financier and art collector. After yet another trip to Europe in the spring of 1925, at the request of the family of Elena Gerhardt, the famed vocalist, Glenway returned to New York and continued to publish poems and reviews in *The Dial* and *Poetry,* as well as the *New Republic, Transatlantic Review, Broom, Contact, The Little Review,* and *Manikin,* which was brought out by Monroe and so-named by him because "a book of verses is like the human body, showing the tissues, organs, and skeleton, commonly in detachable pieces." *Manikin* introduced Marianne Moore's *Marriage* to the public. Another volume of poetry appeared in *Manikin* that year, William Carlos Williams' *Go-Go.*

Despite their poverty, they did not lack sociability. The men enjoyed visits, complimentary tickets to concerts, and sometimes a bon voyage party for a friend. In letters to his father, Monroe wrote: "It was announced last night that Willy von Hoogstraten had been given the New York Philharmonic. Great. We all went together to meet Elly this morning when she returned from Texas. A big party up there tonight. This afternoon we went to tea with Marianne Moore whose mother gave us roasted chicken to take home with us. The Moores have loaned furniture." Elsewhere, "did I tell you that *The Dial* has accepted the first part of Glenway's novel *[Bad Han],* and will run it in January and February and March? Mr. Thayer, the editor, is enormously enthusiastic about it, saying that it is the finest work *The*

Dial has ever received from our American author, and he is starting a publicity campaign about Glenway immediately." Later, when they had moved to a two-room apartment on 17 Christopher Street, this work of fiction was expanded into *The Apple of the Eye*, a novel for which Sinclair Lewis offered the following book jacket comment: "It seems to me to have something curiously like genius." "In a Thicket," a short story by Glenway, was chosen for *The Best Stories of 1924*. But these were difficult days; Monroe's own writing was yielding nothing and he was continually searching for a job. In a letter to his father requesting "a loan in order to survive until I get a job," he describes meeting Hart Crane, "a poet just my age from Cleveland who came to see me yesterday. He is excellent company and a fine writer, I think. He has come to New York to get a job because his father, who is the Crane of Crane's Mary Garden Chocolates and a millionaire, has disowned him because he is a poet [read gay]. Won't give him a penny. Like Albert Sievers' father, who is also a millionaire." But, in the same letter he states that he would not go back to Chicago because, "my literary friends here are immensely important to my life and my development." Also, "Don't dearest Dad, take my troubles too seriously — one must experience everything, and this period of poverty is no less important than more pleasant ones. It's only a matter of time until I 'come through.' I love you, Monie" In May he was hired to write advertising copy for The Coal and Iron National Bank of New York, a job he liked, but which made his life uneventful, leaving him little time to pursue things of interest. Monroe also began designing books, "I now have a connection with the new Dial Press and have already designed for them Glenway's book, *The Apple of the Eye*, and the title page for *The Flaming Terrapin*, which will be out in the autumn, and they have promised me others."

In February of 1925, armed with the confidence typical of young heroes and blessed with a bit of luck, Glenway obtained a one-thousand-dollar advance from the Dial Press and a three-thousand-dollar gift from patron and friend, Frances Robbins. Counting on a favorable exchange rate, Glenway and Monroe decided to join other young expatriates in France.

After an uneventful crossing with calm seas, wonderfully warm weather, and much dancing on the *Ordura's* deck, which was decorated with charming flags and lanterns, Monroe and Glenway arrived in enchanting Paris, a city filled with intellectual and sensual distractions. There they visited the obligatory landmarks, were introduced to Gertrude Stein, played card games with Hemingway at the Fords, and took in art and music, all strong stuff for their eager and ambitious eyes. Wrote Monroe: "We have come back from tea at Olga Sorenson's studio with Katherine Dudley whom we knew in Chicago. We are having a most busy and delightful time; we dined last night and the night before with the Fords who came in from their country place for the week-end. Ford read us the first part of his stupendous new war book, *No More Parades*. Last night we went to a charming little place in one of the caves under the Church of St. Julien le Pauvre, where you sit in a third century torture chamber and listen to delightful old French folk songs sung by a man and

View from the deck of the *S.S. Ordura,* 1925.

a woman accompanied by guitar. We lunch every day at the Dome, the big Latin Quarter cafe where we always meet half a dozen or more friends. It seems impossible to ever exhaust the wonders of Paris where we discover new beauty almost every hour." But this was not good for concentrated work, especially right then when Glenway was working on *The Grandmothers*. Ford suggested that they move south to Villefranche-sur-Mer, a coastal suburb of Nice, which they did by the end of March. Little did they know that their taking two rooms at the quaint Hôtel Welcome in Villefranche would not guarantee the serenity they sought, for their down-the-hall neighbor was none other than Jean Cocteau, a man who soon befriended them.

Built on the steep foothills of the Maritime Alps, Villefranche-sur-Mer is an ancient town that owes its existence to its natural deep water harbor on the

Mediterranean. By train, it is only about five minutes from Nice, and twenty from Monte Carlo. Beginning at the water's edge, the town, with its small pebbly beaches and dazzling white, narrow roads and walls and roofs of vermilion tile, rises vertically conceding to the steep surrounding hills. Further away, the hilly terrain is covered, for the most part, with olive groves and cream-colored villas. The vegetation is almost entirely tropical—consisting of palm and fig trees, pines, cypresses, chestnuts, and eucalyptus, and every variety of cactus. Often the air is sweet with the scent of orange blossoms. Afternoon tea is served in the St. Hospice garden amid a million daisies, geraniums, carnations, and roses. Ripe figs may be picked from overhead. After dinner, a walk in the moonlight may take you along the little promenade around the old citadel, past the old beautiful barracks, and out onto the breakwater. Here one is often greeted by the smell of the wine-presses lodged in the town's narrow streets and occasionally by a breath of delicious wood-smoke. The climate of Villefranche is all one could ever wish for: hot sunny days, cool breezy evenings. Monroe wrote his father: "It is the most beautiful city I have ever seen, without exception. How I adore it here. . . . "

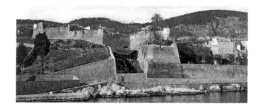

Citadel, Villefranche-sur-Mer, 1925.

In 1925 when Glenway and Monroe arrived in the little port of Villefranche, it had attracted not only the best of the French contemporary avant-garde as in the person of Jean Cocteau and his circle of artists, writers, and musicians but also Igor Stravinsky and Pablo Picasso. As part of the French Riviera and being near Monte Carlo, it also attracted the international rich and those who already were or wanted to be famous. Soon after Monroe and Glenway's arrival and after Katherine Harvey introduced them to French poet and artist Cocteau, who was much talked about in Gertrude Stein's salon, an excited Monroe wrote his father: "And Jean Cocteau, the most celebrated of the younger French writers is here at the Welcome. He is the most dazzling conversationalist in Europe—therefore in the world—(more brilliant,

even, than Marianne [Moore]), and several hours of the day are spent with him. He is making fascinating drawings for the deluxe edition of one of his books. Yesterday

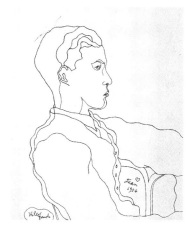

Jean Cocteau, *Portrait of Glenway Wescott*, ink on paper, 1926.

he made a lovely drawing for me. One of his books, *The Grande Ecart* (1922), has just been published in America." Cocteau was thirty-five years old and at the peak of his creative vitality when they met him. Glenway describes him as having "a strange, long Egyptian head, a long French face, with eyes high and a long nose. He was very tall and very inclined to be like a dancer, with extraordinarily elegant sharp movements, particularly in the cutting gestures of his long energetic hands that paralleled his speech pattern: short, rapid sentences, punctuated only by full stops. We made friends very rapidly. He was the most sociable person you could imagine. He got up early every morning to write and dictate letters. He would hold his writing tablet with one hand, his pencil in the other, and write as if he were drawing, and very fast, even putting in little drawings, and all the time talking." Often his visitors included Isadora Duncan, Francis Rose, Igor Stravinsky, Pablo Picasso, and Mary Butts.

At the Welcome Cocteau had a corner room surrounded by a balcony. It was an odd room that always smelled of opium, and from the electric bulb hung little skeleton figures twisted out of pipe cleaners, suspended so that they could

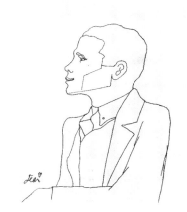

Jean Cocteau, *Portrait of Monroe Wheeler*, ink on paper, 1926.

slowly rotate in the breeze. Strewn about the furniture were innumerable objects made out of match boxes, lumps of sugar, sealing wax, and pieces of corrugated cardboard. All these represented scenes from Greek tragedies. He called them,

"mysteria." From 1910 onward, there was scarcely an opening without Cocteau, the slim young man with a gardenia in his lapel. Around him were Sarah Bernhardt, Misia Sert, Igor Stravinsky, Pablo Picasso, Anna Pavlova, Auguste Rodin, and "tout le monde," as Paris was the world of art and theater. Beginning with posters of Karsavina and Nijinsky for *Spectre de la Rose,* ballet scenario *Le Dieu Bleu,* and a 1913

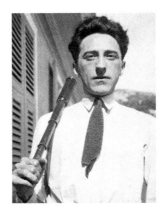

Jean Cocteau, 1928.

collaboration with Stravinsky for the ballet *David,* Cocteau's professional association with Diaghilev culminated in *Parade* (1917), a collaboration with Léonide Massine, Erik Satie, and Pablo Picasso. This association with Satie led to the formation of the group of composers who became known as "Les Six," made up of George Auric, Louis Durey, Arthur Honegger, Darius Milhand, Francis Poulenc, and Germain Tailleferre. With Hilhand and Raoul Dufy, Cocteau collaborated on *Le Boeuf sur le Toit* (1920), a jazz ballet. Next year, using five of Les Six, Cocteau created the ballet *Les Maries de la Tour Eiffel,* which was followed in 1922 by the neoclassical drama *Antigone* (1922), for which Picasso had made sets. This drama so impressed Stravinsky that he engaged Cocteau to prepare for him the text for *Oedipus Rex* (1926). All this while writing poetry, having exhibitions of drawings in Paris and Brussels, taking and detoxifying from opium, and mythifying lovers. All this before beginning his work in film. Jean l'Oiseau, as he was called by friends, he was the bearer of golden eggs. He did not merely live his times, he invented them. Francis Steegmuller, one of his biographers, called Cocteau the creator of the 1920s.

When Glenway and Monroe met Cocteau, Jean Bourgoint was the prominent figure and protégé in his life. Bourgoint had a sister with whom he had shared a small house in Paris, and with beds side by side, they lived in the same cluttered room, enjoyed the same hobbies and strange games, quarreled often. She got into a tragic marriage; later, when Bourgoint became involved with Cocteau, Cocteau wrote

about the siblings' life together in *Les Enfants Terribles* (1929). For this Bourgoint's sister hated Cocteau and accused him of ruining them. While Bourgoint was serving in the military in northern France, by summer's end in 1925, Cocteau helped him obtain a temporary leave so he could visit Villefranche.

Pale, very handsome, broad shouldered, large, and blond, Bourgoint looked like a Greek sculpture. He arrived at the Hôtel Welcome in uniform (plate 3). Monroe was immediately taken by his beauty, but saw that he drank too much Pernod, did opium, and sat indiscriminately among prostitutes, sailors, and odd people at the Welcome's bar. Glenway, however, fell in love with him, and was encouraged by him. As the relationship intensified, Cocteau showed signs of jealousy. And so did Monroe, their agreement after the Elly Ney incident notwithstanding. In an interview with Jerry Rosco, Glenway stated that Bourgoint became his model for the character Timothy in chapter seven of *The Grandmothers* (1927). In *Continual Lessons*, (1990), Glenway recalled that "On a beach at Palavas-les-Flots, there was a place where someone's vineyard came right down to the sound — one of the places where Jean Bourgoint frustrated me." Bourgoint also inspired an imagist poem, "Venus on the Shore." The one-page typescript is dated Villefranche-sur-Mer, 1927, and bears Glenway's written note: "A poem about Jean Bourgoint not for him — he

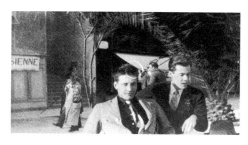

Jean Bourgoint and Glenway Wescott,
Villefranche-sur-Mer, 1925.

knew only a few words of English." This poem appears to be one of the few poems Glenway wrote in the late twenties, his most prolific period as a writer of fiction. Many years later, when Glenway returned to France, he visited Cocteau whereupon in walked Bourgoint, in better shape than expected but ugly and disheartened: his large ill-kept hands jerky at the end of his long thin arms; his teeth wide apart and gray; only his pallid eyes ablaze. Now a Trappist monk, he assured Glenway that he was at present a model to youth. At this meeting Bourgoint was

"absurdly resentful of and mystified by" Glenway's long neglect and was rather more affectionately interested in news of Monroe. According to Steegmuller, Bourgoint "belonged to that category of men — that of parasites: he was beautiful, sunny, candid, 'silly,' a simpleton, slothful, greedy and charming, with no ambition whatever, either for glory or ruin: as it turned out, the parasite, far from being a victim, eventually achieved a remarkable salvation." Glenway once referred to him as "one of God's fools." As Raymond Radiguet before him and Jean Desbordes, Marcel Khill, Jean Marais, and Edouard "Doudou" Dermit after him, Bourgoint was one of Cocteau's "rescuing angels" who, in turn, became mythified as part of Cocteau's life, a life in which myth was intertwined with poetic truth.

Though fascinating and of great interest, the effervescence surrounding Cocteau's life and that of his friends did not keep Monroe and Glenway from finding time to meet other guests at the Welcome or from exploring the French Riviera and surrounding little towns such as Pornic and San Martin–Visubie. Occasionally they went to Paris to see Bernardine Szold, Marguerite Namara, Nancy Cunard, Harry Lachmann, and Eugene MacCowan, a talented American painter living in Paris who did an oil portrait of Monroe. In June of 1925, Glenway's literary agent, Lloyd Morris, joined them on a trip to Nîmes to see their first bullfight in an old Roman arena. And in September Monroe and Glenway went on their first trip to Italy, visiting Pisa, Rome, and Florence.

They returned from Italy to their friends in the Riviera, which was already filling up for the winter. "Today Glenway and I went to a big luncheon at the Vignals, very amusing and gay, met two more counts who've invited us to dinners. Louis Gautier Vignal whose father, the Count, has a magnificent establishment at Beaulieu. The Countess is English and very charming. Louis Vignal took us to tea at Vangade's in Nice where we met Stravinsky, who also lives there. At the Vignals' we met the Maleyssies, who also invited us to spend a week at their villa at St. Raphael. The Count's father is the Marquis de Maleyssie, a lineal descendent of Joan d'Arc,

no less, and his mother, a Vanderbilt. The other evening we dined at Beaulieu again with Lady Hatfield, the Fortas, Sam Barlow, and others. Tomorrow we are tea-ing with an American woman, Mrs. Barton-French, who has a villa across the harbor from us on Cap Ferrat." At that time Cap Ferrat was also home to W. Somerset Maugham, the English literary giant who years later was to befriend Glenway and become one of the great influences in his life.

Early November brought with it new guests to the Welcome, among them were Peter Morris (plates 17, 18), a charming English painter and traveler they had met in Pornic and who arrived with his lover Paul Odo Cross for a several-day visit. They were followed by Rebecca West and Glenway's literary agent, Lloyd Morris. But their most interesting guest that November was Paul Robeson, whom they had met in New York and who had arrived with his wife Eslanda from London where he had been playing *Emperor Jones* to great acclaim (plates 31, 32). Monroe conveyed the excitement of Robeson's visit to his father in the following terms: "Did I write you about him from New York? He has been in London playing Emperor Jones where he had an enormous personal success. He is, as you may remember, a Negro—probably the most extraordinary one alive. He is twenty-seven years old. He went to Princeton, took B.A. and Phi Beta Kappa at Rutgers where he got three letters a year and was twice on Walter Camp's All-America football team, then graduated from Columbia Law School and was admitted to the New York Bar and offered a New York District Attorneyship. But he decided he wanted to act, joined the Provincetown Players, and last year played *The Emperor Jones* in London. And then came the singing. I first heard him last winter at a studio party at Betty Salemme's when he sang some Negro spirituals. I was more thrilled than I have ever been by any human voice, and said at once 'American Chaliapin' and since then every critic in New York and London has said the same thing. Victor signed him for records on the same royalty basis as Galli-Curci and Chaliapin. He has just completed arrangements for a European tour in April and May—and now Reinhardt wants him to play *The Emperor Jones* in Vienna next fall, in German (which he happens to speak).

He has a most intelligent and cultured wife, and they are thoroughly delightful. Tonight we are giving dinner to them—Count de Vignal, Count and Countess de Maleyssie, etc. Over here you know, there is no race barrier, and blacks are judged by their intelligence and they should be. Paul is singing in Chicago February Tenth at Orchestra Hall. Go, all of you, and after the concert see both Paul and Eslanda because I've told them to expect you."

That December, "our beloved Mary Butts arrives to stay with us at the Welcome through Christmas." Very well known in the 1920s and 1930s, the English novelist and wit Mary Butts was rather English in appearance, spoke with a cultured high-pitched voice, had pale skin with freckled red cheeks, and often wore a single jade piece that hung from one of her ear lobes, often entangled in her untidy red hair (plates 17, 52, 53). Most of her friends regarded her as somewhat frenetic. She began as a student of classical history, but soon became equally interested in magic and the supernatural. She was a talented, manipulative, and complicated woman who derived enormous pleasure in finding someone psychologically sick and, by studying them, ascertaining whether there was a way out, "a feeling very much mixed up with sex—bed not necessary—but desirable, for it makes things work better. That is, any power I have seems to work better under those conditions. I have always wanted to make my lovers well, sense the liberated powers in them...." Before arriving in Paris, Butts had been married to the publisher John Radker by whom she had a daughter. She fled to the Continent with "a tall Scott who practiced black magic and took drugs" and who died suddenly soon after their arrival in Paris. There she contributed to Robert MacAlmon's *Contact* magazine, and Jean Cocteau consented to illustrate her *Imaginary Letters* (1924), the first book he illustrated but had not written himself. The following year, when she met Monroe and Glenway, her *Ashe of Rings* was published "with a plethora of ancestral shenanigans that included witchcraft, incest, heathen gods, adultery, nepotism, and spiritualism." While staying at the Welcome, and between writing and smoking opium and arranging the misamours of her friends and lovers, she delighted her company by

reading aloud unforgettable English verse and her translations of Cocteau pieces. It was through Mary Butts that Virgil Thomson — and many others — first experienced the "opium world," though they soon discovered that part of her magic also came from religion and great poetry. "She was strong medicine," Thomson said, "a strong woman hardened by personal tragedy, possessed with formidable mental powers and inflexible habits — a veritable storm goddess surrounded by cataclysm." In other words, she was fun company.

Glenway once recounted that Cocteau began taking opium after his great friend and lover Raymond Radiguet died of typhoid fever in the water closet of a small, third-class hotel. A gifted boy-novelist, Radiguet was referred to Cocteau by the poet Max Jacob in 1919. A sturdy little boy with a pretty face and a walking stick, at the tender age of sixteen he knocked on Cocteau's door and offered him a brilliant manuscript. Radiguet ended up having an enormous influence on Cocteau. With only an ordinary education, he identified Cocteau's affectation, mannerism, repetition, and poetical fantasy, and made him write short sentences with impact. In return Cocteau built him up into a very famous young writer, learning much in the process. Glenway said that Radiguet's *The Devil in the Flesh* (1923) is one of the most beautiful books imaginable. Radiguet's death nearly destroyed Cocteau.

While working on his play *Orpheus*, Cocteau was frequently visited by George Auric and Christian Bérard. Auric, a member of Les Six, which also included Francis Poulenc, was a follower of Erik Satie and a rabid antiWagnerian. Devoted to Cocteau, he contributed music to Cocteau's *Le Boeuf* and *Les Maries*, as well as music for the films *The Blood of the Poet* and *The Beauty and the Beast*. Bebe Bérard, as Christian Bérard was known, was a bear of a man who was regarded as a neoromantic, in counter-position to the emerging surrealists (plate 39). This group of neoromantics also included Pavel Tchelitchew, the brothers Leonid and Eugene Berman, George Huquet, and Francis Rose. Their favorite subjects were people or places, which they rendered naturalistically and at the same time infused with personal sentiment so that "every landscape had a 'genius loci' and every person his par-

ticular pathos." All created closed worlds somewhat poetically conceived. Whereas Bérard began with dreamy, isolated figures in ambiguous settings, after 1935 and under the spell of opium and society living, he became a most successful fashion artist and stage designer whose costumes and decor for the film *The Beauty and the Beast* prompted Cocteau to say that Bérard was a fellow master of fantasy, an antimodern, a neobaroque successor to the Picasso of *Parade*, who gave fantastic cinema a degree of nobility never before achieved. Tchelitchew had originally focused on seemingly alienated men from the circus, or the demi-monde, and later turned to creating images of horribly distorted figures trapped in nature. Both Bérard and Tchelitchew illustrated books published by Monroe's Harrison of Paris. Bérard died young, but Tchelitchew, with Monroe's help, immigrated to the United States.

George Auric, 1926.

In March of that year, Lloyd Morris, Glenway's literary agent, returned from the United States and, in Monroe's words, "being very fond of us, brought us quantities of presents — things we can't get in Europe, like shirts with collars attached, etc. And a stack of new phonograph records a foot high. Glenway got a scarf from Sulka's, a shawl rather, and a gold manuscript binder with his engraved name, and I got a stunning belt with my initials on the silver buckle, three shirts and six pairs of silk BVDs, which species of underthing doesn't exist over here, and a wallet, and a hundred dollars worth of luxurious cravats for us both, etc. Best of all, he brought Glenway a contract from Harper's for his work of the next five years, with good royalty rates, and a guaranteed advance of $2,500 a year, and no option on future work, which leaves him free to drive a much better bargain when the five years are up. This of course is far better than any of the offers he has had from Scribners, Harcourt Brace, Doran, and Knopf, and he is signing it at once. That he should be

able to get this sort of contract on the strength of one book — *The Apple of the Eye* — is a magnificent tribute, don't you think?" *Like a Lover* and *The Grandmothers* were not finished yet. One wonders how they got anything done at all given the intense sociability and other forms of distraction at Villefranche, including trips, guests, and regular week-long visits to Paris, and so on. But Harper's had bet on the right horse.

The gods continued to smile upon Glenway: he received a cablegram from Harper's saying that they had succeeded in getting *The Grandmothers* away from MacVeagh at *The Dial,* but that it would not be published until sometime in 1927. With this good news, they were excited and looking forward to visiting Vienna,

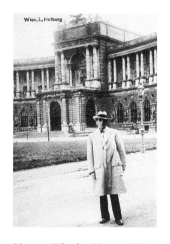

Monroe Wheeler, Vienna, 1926.

where they would hear glorious Mozart operas and see ravishing pictures. Three weeks later Monroe's father received a telegram from Vienna: "Had appendicitis operation Saturday. Doing splendidly. Can you spare hundred dollars. Care Glenway, Hotel Sacher, Vienna. Love, Monroe." At the time, Monroe weighed less than 120 pounds and was very anemic. For his recovery and convalescence, they went to Aix-les-Bains, a resort town not far from Geneva. There they were visited by Bernardine Szold and Frances Robbins and her sister, Miss Lamont, who had come over to Europe for a year.

On March 28, Monroe was well enough to travel to Paris to witness and enjoy George Auric's new ballet, *Pastorale,* performed by the Diaghilev company. They also went to see Florence Mills' *American Negro Revue,* as well as Mozart's *Cosi Fan Tutti* at the Opera Comique, and Stravinsky's *Les Noces,* "another ballet evening, this latter being the most thrilling piece of modern music I have heard." To his father Monroe wrote: "Bernardine gave us tea, Jean Cocteau a luncheon, etc. At this time of the year, at the height of the season, Paris is so ravishing, so beautiful, and so costly, that it is ruinously expensive for us to stay for more than a week. I now know

that the best way to enjoy Paris is to go, as we did, for a few days, concentrate all one's social activities in a few days, and then come back to the lovely serenity of Aix or Villefranche. We brought Bernardine Szold back with us [to Aix] for a few days so that Glenway could read some of *The Grandmothers* to her. I play tennis every afternoon, weather permitting, and am taking lessons from a 'pro.' You have no idea how lovely it is here; the air is more fragrant than any I have ever smelled—heaven only knows where so much natural perfume comes from. While Bernardine was here we met Leonora Hughes and Avery Hopewood. We are going up to Paris again on the 14th to see the first performance of Cocteau's new play *Orpheus*, but this time we shall stay only three days." By mid-July, Glenway and Monroe were back at the Welcome, where they resumed their routine from preVienna days, often in the happy company of Jean Bourgoint and Jean Cocteau, who enjoyed sunshine and relaxation after the hectic premiere of *Orpheus*.

In August, tired of the noise and expense of the Welcome and seeking more privacy, Glenway and Monroe rented a small "villa" high on the hillside above the busy quai of Villefranche, with its hotels—of which the Welcome was the most prominent—cafes, shops, and . . . a tiny abandoned church where the fishermen stored their nets. Next to the quai, fishing boats bobbed with their masts a-creaking. Over Villefranche and looking out toward the sea, from the salmon sun-drenched windows of this tiny villa one could see, on either side, far into the horizon where the mountains disappeared into the sea. Sheltered from the northern cold winds, the villa had a vine-shaded patio and an attractive semitropical garden that was "full of flowers and adorable lizards, dozens of them from five to eight inches

La Cabane, Villefranche-sur-Mer, 1926.

long, who play around on the stone walls in the sunshine. I wish I could hand you some luscious ripe figs from our tree; I eat about twenty a day." They named the

house "La Cabane." It came with Ida, a housekeeper and cook, whose baked peaches stuffed with chopped green almonds were to die for.

When guests arrive at La Cabane, they were entertained in the out-of-doors patio and, often, afterwards, would go to the pebbly beaches in Villefranche, either

La Cabane, Villefranche-sur-Mer, 1926.

to the "plage dessous la gare" or, further away, to the beach of Juan-les-Pins. Monroe always took his camera and enjoyed photographing his guests as they lounged seminaked on the beach. These beach excursions often included, in addition to Monroe and Glenway, Lloyd Morris, Marise Robinet Durise, Thomas Pinkerton, and Jean Bourgoint and his friend Jean Guérin. Sometimes Maurice Sachs and Jean Cocteau went along. Other times these outings included only Frances Robbins and Bernardine Szold's young daughter, Rosemary Carver.

Somehow the boys always found time for work. In a late September letter to his father, Monroe wrote: "I am now translating into English Madame de La Fayette's 'Princess de Montpensier,' which is one of the two most beautiful stories in the French language, and as far as I know has never been translated into English." He does not mention the other. "I have just received Elizabeth [Roberts] *Time of Man*," he continues, "but have not yet finished it. I find it astonishingly beautiful and moving, don't you? Do write her that you like it — if you do — because it would please her. Did I tell you she now has tuberculosis. She seems to be one of those unfortunate women who live on the verge of death for sixty years — and do ten times as much as their healthier contemporaries. Glenway is going to review the book for *The Dial.* Am having another every-day-for-two-weeks siege with the dentist in Nice. I have a sort of gum trouble that has been bothering me. Isadora Duncan and a friend came yesterday to try to get us to motor to Marseilles with them to spend a

few days there, but as we are in no position to afford such an expedition, and as she admitted she only had a thousand francs, we thought it best to decline. Anyway, I am up to my neck in my translation and I don't want to leave it. I also made the first draft of the English translation of Jean Cocteau's play *Orpheus,* which Glenway had promised to do for him."

While Bourgoint was still on the scene, another "angel" entered Cocteau's life, manuscript in hand. It was Jean Desbordes. A Protestant, this young man from Vosges was barely twenty years old in 1926 and had lived all his life in the country, seeing nobody but his mother and his sisters, reading little and covering pages with barely decipherable handwriting. Greatly affected by Cocteau's *Le Grande Ecart* (1922), he at once wrote Cocteau declaring that his life was in his hands. Cocteau replied begging him to subdue his fervor. After Desbordes completed his military service, Cocteau introduced him, as he had Radiguet, to the hectic life of Paris where he was supported by Cocteau and was part of his circle. For a while Cocteau and Desbordes were guests together in Channel's elegant house. Cocteau's relationship with Desbordes was a bit more tranquil than his relationship with Radiguet, but although this angel did not drink, he did not behave any better than his predecessors, so once again there were constant scenes and as many reconciliations. Upon deciphering Desbordes' manuscript for *J'Adore,* Cocteau at once recognized him as another genius and resolved to help him find himself without sacrificing his freshness. Once again Cocteau wrote the preface for a young writer's debut, defending him from the charge of being an infant prodigy and deflecting comparisons to Radiguet.

J'Adore was published by Desbordes in 1928 and all Catholic critics, with the notable exception of Max Jacob and Pierre Reverdy, denounced it. Jacques Maritain, a longtime friend of Cocteau's, was deeply shocked by it and wrote such a severe review that it ended their close friendship. Desbordes had written in *J'Adore* that he did not want God "shut up in a church"; now Cocteau, strongly influenced by Desbordes' hatred of dogma and his own more pagan religion, wrote: "Let

Maritain return to his Christian philosophy, and I will return to poetry." As a mark of this change and his renunciation of the sacred heart, symbolized by the red heart worn by Père Charles Heurion, which so much impressed him, Cocteau now gave up putting a tiny heart beside his signature and for the rest of his life put a star instead — "a star," he said, "suggested by a scar on Apollinaire's forehead."

Cocteau's relationship with Desbordes was quite different from that with Radiguet, from whom Cocteau claimed to have learned much and in whom he saw his own influence induce some degree of self-discipline. But with Desbordes, Cocteau made no such claims, stating that this young man's nature and talent simply refreshed him as a "fount of youthful innocence." With the 1934 performance of *La Machine Infernale* at the Comedie des Champs-Elysees, Cocteau found a new angel to replace Desbordes, who had had faded from his life. Although it only ran for sixty-four nights, *La Machine Infernale* brought Cocteau Marcel Khill, the youth who played the tiny part of the Corinthian messenger. He was Arab by origin, his real name being Ke'lilou, and besides being a dark-skinned beauty, he was an extremely agreeable young man.

Cocteau and Desbordes remained friends. In May of 1939 war broke out and Jean Desbordes and Marcel Khill were mobilized; Cocteau, in Paris, regarded his life with despair. Desbordes had married and soon afterwards joined the Resistance. In the summer of 1944 he was captured. "Desbordes died shortly after the liberation of Paris," Cocteau told Fraigneau, "tortured by the Gestapo, rue de la Pompe. This child, who could not bear so much as a pin-prick, died in appalling suffering without giving away the name of a single one of his comrades. One must salute him as one of the least known heroes of the Resistance." Close to the Liberation as they now were, none of Desbordes' friends dared to give public honor to this extraordinary man, a warrior-poet, whose heroic death saved so many.

By the end of 1926 a finished draft of *The Grandmothers* was completed, and January of 1927 found both Monroe and Glenway at New York's Hotel Lafayette, at Ninth

Avenue and University Place. Here Glenway was to meet with his editors at Harper's concerning proofs and other matters related to the impending release of his book. One day, while Monroe was out, the front desk informed Glenway that a certain Mr. George Platt Lynes and a Mr. Wesson Bull (whom George was "seeing" at the time) were there to see him. They claimed to be friends of Miss Bernardine Szold. Indeed, George had met Szold in the fall of 1925, in Paris, at Gertrude Stein's. Knowing that Glenway and Monroe would be in New York, Szold wrote George and suggested he "look them up." Many years later when he glanced at a photograph of Glenway, Rawlins Cottonet, and Monroe on the Promenade des Anglaise, in Nice, taken in October of 1926, Glenway remarked that George had fallen in love with Monroe at first sight (plate 63). Glenway remembered clearly "George's bowler hat; flushed teenage complexion; his whistle of love; and his expression: 'this is the man for me.'" George met

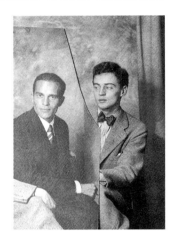

Monroe Wheeler and George Platt Lynes, montage, 1927.

Monroe the next day when he went alone to the apartment for a cocktail and then accompanied Monroe to the latter's dinner engagement uptown. "In the subway on the way there," Monroe added later, "he declared himself in a most open and extraordinary way. He just took for granted that I was to be his." George had fallen hard for Monroe, who, George insisted, resembled the image of the sculptured head of the ancient Egyptian prince Ikhnaton of which he owned a cast. Monroe, on the other hand, who throughout the last fifteen years of his life concealed his homosexuality and worked hard at being accepted in straight society, was fascinated by this beautiful and confident gay man, not yet twenty, who took his physical appeal for granted and his accepted homosexuality so naturally. This, together with the discovery of their mutual love of books and classical music, as well as friends they shared in Stein's circle, further excited him. But it was George's full, luscious mouth

and his wasplike waist that drove Monroe into ecstasies of physical pleasure. Even though they were very different from one another, Monroe hadn't felt anything like this since he had met Glenway eight years earlier. Glenway, sensitive and prone to some pessimism, saw his future with Monroe threatened once again. As had been the case with Elly Ney, he sincerely hoped that, given the distances involved, this powerful infatuation would not last. Who was this youngster, anyway?

This impetuous youth was born George Platt Lynes on April 15, 1907 in East Orange, New Jersey, to Joseph Russell Lynes, a twenty-five-year-old lawyer soon-to-be minister, and Adelaide Sparkman Lynes, a twenty-four-year-old teacher and something of a beauty who later played the role of a minister's wife with a "gracious reluctance." His father turned to the ministry because the practice of the law, in his view, was not "a moral profession." In addition to lawyers, George's paternal forebears included farmers, businessmen, and "men of creative genius" like his father's mother's father, George Platt, who in the 1830s immigrated from London to New

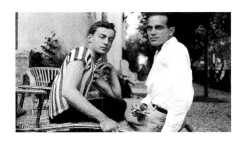

George Platt Lynes and Monroe Wheeler, 1928.

York where he became a successful interior decorator and a painter of small, charming watercolors. George was named after him and, apparently, inherited his talents. George's mother, Adelaide, was born in New York, the daughter of an "impractical businessman with roots in the South and Ellen Fulton, a New Yorker who was distantly related to the accomplished painter Robert Fulton, better remembered for his steamboat." Theirs was a good middle-class family with solid nineteenth-century American values (plate 132).

As his early and adolescent photographs show, George was a remarkably beautiful child, and, according to his younger brother Russell in an unpublished biography of George, "he was also a difficult, if not a neurotic, child. He wanted to be both inde-

pendent, even defiant, and forgiven, like most children of spirit, and he liked to speak his mind which sometimes got him into embarrassments." Russell also relates a tale about his brother's sense of childish fantasy: at age five, George told his barber that he was not a minister's son at all but a Russian prince who had escaped and was brought to Great Barrington and left there temporarily with the minister and his wife. Russell notes that "it was the sort of fantasy that forever pursued him — and that he pursued." When he was thirteen, two years before the family moved to St. Paul's Church in Englewood, New Jersey, George was sent to the Berkshire School in Sheffield, Massachusetts, scarcely ten miles from the Great Barrington rectory of his childhood. Unlike other private schools of better standing, Berkshire in those days was a small preparatory boarding school with a borderline reputation that admitted "problem boys." George was offered a "scholarship," an euphemism for reduced fees made available since his father was a member of the clergy and the headmaster's friend and occasional golfing partner.

George did not have an easy time of it at Berkshire. Russell recounts that he "threw a ball 'like a girl,' a dead giveaway to other 'red blooded' boys, and he was a poseur who even in school photographs struck an attitude that set him apart. He refused to take part in sports of any kind." Because of his overt effeminacy and striking good looks, the "red blooded" boys often beat him up and made his life generally miserable. "Some of them," George later recalled in a letter to his good friend Bernard Perlin, "always [came around and] hated themselves in the morning, but almost always came back for more."

Although regarded as academically gifted, George lacked discipline and did well only in subjects he liked. He was fascinated by Greek mythology and worked harder on his poetry than on his algebra or Latin. His introduction to the arts occurred informally through friends, who, as far as his favorite reading was concerned, led him to French and Russian authors, rather than to the required English classics. In his tastes he was particularly influenced by a bright young friend named Wesson Bull, the editor of the school's literary magazine *The Dome*, to which George contributed. One of his published pieces, "And I, Tiresias," suggests he was reading

Eliot's *The Waste Land* ("I Tiresias, though blind, throbbing between two lives / Old man with wrinkled female breasts."). This particular contribution regarding the

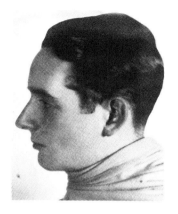

myth of the half-male, half-female seer, with whom George may have felt an affinity, earned him, according to his brother, the derisive nickname "Tess," short for "Titless Tessie." His other contributions to *The Dome* were verses that showed strong imagist influence, particularly that of Hilda Doolittle. In recalling his school days for *Bachelor* magazine (April, 1937), George wrote: "In private schools I was the sort of bright unpopular youngster who makes up for being lonely by elaborate make believe about the arts and a cult of certain writers, such as Cocteau and Stein." In

Wesson Bull, 1925.

addition to Wesson Bull, who was a few years older than himself, other close friends at Berkshire included Lincoln Kirstein, Adlai Harbeck, and Paxton Howard. With Harbeck's help, George started As Stable Press. The first pamphlet they produced, "Genesis of Peace," by Paxton Howard, was met with severe disapproval and was confiscated by the headmaster.

Unable to graduate with his class of 1925 because he had not completed the required courses, George's parents decided, "after consulting God, a famous psychologist, and their bank account," to send George to Adelaide's Cousin Kate (Mrs. Walter Hardy) in Paris, where he would complete the necessary courses that would facilitate his admission to Yale, where his friend Wesson Bull had gone. George

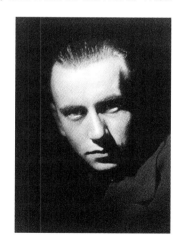

Adlai Harbeck, 1925.

departed for France on the HMS *Mauritania* on April 11, 1925. From the ship he wrote his parents: "Adlai [Harbeck] has just left me. In a few minutes we sail. There is not much I can say. My ears are burning, the pen shakes in my hand. I am hoping

for many things: Someday there will be satisfaction for us all. Now, it is the last frightening moment and the iron-ore water is of the same stuff as my mind; I am drugged, I cannot think. I wish I knew so many things."

It was clear to all concerned that once in Paris George had to fulfill two basic tasks: make up the deficit that stood between him and Yale and, more importantly, "grow up." The former was eventually achieved somehow, and chances for the latter, as luck would have it, were soon at hand. It so happened that the Hardys were Gertrude Steins' neighbors and they took George with them to 27, rue de Fleurus for tea. He was in awe. Wesson Bull, who had given George a copy of *Tender Buttons* (1914) to read at Berkshire, also told him about her famous salons and her life with Alice B. Toklas. George had just acquired *The Making of Americans* (1925) and was fascinated by her eccentric rhythms and the obscurity and inventiveness of her prose. Even so, he was not prepared, despite his wild imaginings, for the reality before him. Variously described as "a sexless, corpulent monk" (Van Wyck Brooks), "a small but monumental sibyl" (Virgil Thomson), and "a quick and original intelligence that was an iceberg of megalomania" (Edmund Wilson), she was known to preside over her gatherings by sitting implacably on her high-backed chair with her poodle Basket in her lap, surveying and mesmerizing her collection of equally famous friends with her talk, surrounded by objets d'art from the Renaissance and the Middle Ages and paintings and sculptures by her friends Pablo Picasso, Henri Matisse, Georges Braque, and Juan Gris.

A few weeks after a second visit "to tea," George wrote Miss Stein asking if she would be willing to sign a copy of her *The Making of Americans* and give him "the pleasure of seeing you again for a few minutes," signing Baby George, an epithet she had coined and of which he grew tired before she did. Miss Stein, and especially Miss Toklas, liked George and soon he was invited to pay her court at her intellectual salon. In *The Autobiography of Alice B. Toklas* (1933), Stein wrote that during the 1920s "all the young men [René Crevel, Ernest Hemingway, Jean Cocteau, Virgil

Thomson, Aaron Copland, Pavel Tchelitchew, etc.] were twenty-six years old. It was the right age for the time and the place. There were one or two under twenty, for example, George Lynes, but they did not count, as Gertrude Stein carefully explained to them." Although he presented himself as a poet, Gertrude found him amusing and ornamental. He, on the other hand, worshiped her.

George's beauty did not go unnoticed in Gertrude's salon. The poet René Crevel took an ardent fancy to him, showering him with letters, both in French and English, that began "Ma petite colombe cherie" or "Dove." This correspon-

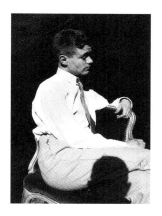

George Platt Lynes, *Portrait of René Crevel*, 1928.

dence began in Paris and continued well into 1929. Alice Toklas had a particular fondness for Crevel, but Stein described him as "young and violent and ill and revolutionary and sweet and tender." In 1926 George published a pamphlet by him. Many years later, in a letter to Bernard Perlin, George assessed Crevel as "the author of a dozen unreadable surrealist short novels but whose life was all charm charm charm and LOVE LOVE LOVE and T.B. and drugs and calamity in general, ending in suicide." Crevel belonged to Virgil Thomson's group of friends which in the 1920s included the painters Pavel Tchelitchew, the brothers Eugene and Leonid Berman, Kristians Tony, and Christian Bérard. A close friend of Tchelitchew's, Allen Tanner, a young American pianist studying in Paris, also befriended George at that time. Pavlik, as Tchelitchew was affectionately called, and Allen lived on Ford Madox Ford's farm near Paris, and eventually bought it from the novelist and editor of *Transatlantic Review*, a Paris literary magazine.

Other lasting friends George met at rue de Fleurus were Edith Finch and Bernardine Szold. Finch, a young New England bluestocking now living in Paris, was distinguished by her superior intelligence, unconventional taste, and adventurous spirit. When George met her she had a fondness for riding horses by standing on

their backs. She was so proficient, she was asked to join a circus. Later, she became a backer of George's As Stable Press when he revived it in 1926. In the early 1950s Edith married Lord Bertrand Russell, the philosopher-mathematician and Nobel Prize winner, and became Countess Russell. Bernardine Szold was a young American journalist in Paris who claimed to have originated the idea of "Letter from Paris" (for which Janet Flanner became known). She introduced Barbara Harrison to Monroe Wheeler and Glenway Wescott and facilitated George Lynes's first encounter with Monroe. For these introductions Bernardine earned their lifelong gratitude. She was also the mother of Rosemary Carver, who later became George's model and assistant.

Edith Finch, 1925.

By the spring of 1926 it was clear that George was going to be admitted to Yale that fall. He returned to Englewood, New Jersey, and with the help of Adlai Harbeck and Edith Finch revived As Stable Press with the publication of Stein's pamphlet "Descriptions of Literature," which featured on its cover a drawing of a double head by Tchelitchew. Arrangements for this publication had been made before George sailed back from France. For questions related to the printing, subscriptions, and general advice, George had turned to Stein's New York friend, Jane Heap, who, with her friend Margaret Anderson, ran a literary magazine called *The Little Review*, as well as a bookshop and a gallery. On the day George turned nineteen, he wrote Gertrude: "'Descriptions of Literature' goes to press day after tomorrow and will be ready for distribution by the first of May. Subscriptions are coming in well. . . . This will be soon a rare and unattainable edition."

All the while, George started "hanging out" in New York, and he managed to find introductions to a cultural salon where he was welcomed not as an ornament but as a "promising young man." It is very likely that George met Muriel Draper

through Jane Heap or Lincoln Kirstein, and through Muriel's salon George was permitted access to the "Upper Bohemia of the Arts" in New York. For one of her meetings, Draper arranged to have "Descriptions of Literature" read to her friends in Yiddish. She was an eager promoter of the arts and those she regarded as the talented young. In Muriel's circle George's closest friends were Lincoln Kirstein, Buckminster "Bucky" Fuller, Virgil Thomson, and Max Ewing. A pianist and composer, Max Ewing had just played at the celebrated premiere of George Antheil's *Ballet Méchanique* at Carnegie Hall. Max was also an eccentric photographer—he always photographed everyone he knew in his apartment in Greenwich Village before the same window shade on which was painted a scene of Venice. Later Julien Levy exhibited his photographs, but Max's career failed its early promise, and he committed suicide by walking into a lake near his native Kansas City, Missouri.

In letters to Stein written that fall, he poured out the loneliness, frustrations and disappointment he felt at Yale, "This place is infuriating!" Nevertheless, he continued working on the projected pamphlets. In October George published René Crevel's "1830" with a drawing by H. Phelan Gibbs and Ernest Hemingway's "Today is Friday," with a cover drawing by Jean Cocteau whom, George too late discovered, Hemingway despised. In a December 1, 1926, letter George wrote Stein: "Adlai and I paid mostly for yours. Edith paid for the Crevel and the Hemingway. So far they are not self supporting . . . " He also informed her that a small advertisement he ran in *The Dial* gave him "much satisfaction" because it produced a number of sales, especially of "Descriptions of Literature."

The week before Christmas, George arrived unannounced at his father's rectory with all his clothes and books and blankets, and bibelots. Without warning anyone, he had quit Yale. In January 1927, George informed Gertrude that he and Edith decided not to publish any more pamphlets because the medium was "too insubstantial, inconsequential, and altogether unsatisfactory." He also told her he would enroll at Columbia to learn business administration and open a bookshop, possibly in New York City. In his early 1927 letters to her, George made no mention

of having met Monroe and Glenway, but he did indicate that "these were extraordinary times. Everything is finished," he wrote in his customary hyperbole, "Or else everything is just beginning." While the reasons for this concealment were probably interesting and valid, his sense of change proved to be, in retrospect, absolutely correct: falling in love with Monroe and its eventual consequences was to be the most important single event of his entire life.

Monroe and Glenway did not stay long in New York on that 1927 trip. After attending to business at Harper's and visits to their respective families, they returned to Europe on the SS *France*, on February 19. On that same day George sent Monroe a telegram: "Monie, darling—I cannot write a letter now. You are too immediate, too close; the break of your departure too sudden. I cannot tell you, though you will guess, how horrible, how painful, it is going to be waiting for you all the months between now and November. I cannot give you up. I will not give you up. I think I shall never again know the joy and the unhappiness that I have known this last week. I think that I shall never again experience the thrill of eyes I felt when you looked at me. Never forget me, darling; think of me and let me hear from you. I will write letters when I am calmer. Always adoring you, George." Such intensity was new to him. George realized he was totally smitten; nothing else mattered. As never before, a sobbing George poured out his intense emotional feelings to a confused and forgiving father.

Monroe and Glenway returned to France via England, where in London they met with Bernardine Szold, British painter and good friend Tony Butts, and magazine and newspaper editors and correspondents. Then on to Paris, by night boat from Southampton to Le Havre, where they met Jean Cocteau, Mary Butts, Mary Reynolds, and Jean Bourgoint, and then on to Villefranche where "Ida had a magnificent dinner of lobster and roast guinea hen and pastry of her own making, all waiting for us. Today, for the first time since we returned a week ago it is raining. The weather has been divine, and the violets and mimosa perfume the air of the

entire hillside. We have several beds of violets which look like purple carpets, so thick are the blossoms. Frances Robbins, now that we are back, is staying at a new hotel about five minutes down the hill, so that she is with us a good deal." And so was Mary Reynolds (plate 59), sister of a Chicago millionaire and a beautiful World War I American widow, who shared an estate with Jacques Guérin, a gay man, in Cap d'Antibes, one of the most beautiful places on the Riviera. Guérin's father, known as the "shoe king" of France, was recently deceased and left him a sizeable fortune. Not only beautiful, Mary Reynolds was also a lady of "distinguished looks and presence," who was also known to occasionally engage in boisterous merry-making and to frequent bars. For many years she had been the mistress of Marcel Duchamp, whose *Nude Descending a Staircase* provoked the delightful "noise" of the 1913 Armory Show in New York. In addition to visits with the usual friends at the Welcome, guests at La Cabane that spring also included Paul Robeson and his wife, Eslanda; Bernardine Szold and her daughter, Rosemary Carver; American sculptor Arthur Lee, his wife, and their daughter, Ingeborg Gloria Lee; and Rawlins Cottonet and his sister "who were there for two weeks in April and practically our entire time has been consumed in showing the Riviera, as it was Miss Cottonet's first visit here.

Dick Halliday,
Villefranche-sur-
Mer, 1928.

They left before yesterday to motor through Northern Africa with Mrs. W. K. Vanderbilt, Sr." Other visitors were Hope and Walter Weil, she being a photographer they had met in New York, and Kate Lawson, another of "our oldest New York friends." Monroe also received a two-week-long visit from an amiable gay friend from Chicago, Dick Halliday, who years later married Broadway star Mary Martin and settled down with her on a large spread in central Brazil. Early summer fireworks were provided by Paul Soutter, a friend of Jean Bourgoint, with whom both Monroe and Glenway had strictly physical "affairs," at different times, that produced some excitement without any consequence (plates 23–27).

It is remarkable that in the midst of so much sociability, Glenway had the discipline and determination to embark on new literary projects so soon after the release of the widely acclaimed *The Grandmothers*, which earned him the Harper's Prize Novel Contest of 1927, when he was only twenty-six. Novelist and critic Lewis Bromfield called the work "one of the most beautiful books I have ever read," while a *New York Herald Tribune* review headline proclaimed Glenway "A Celebrity at Twenty-six." Clearly he had become one of the top American expatriate writers of his day.

In the first few months after Monroe and Glenway's departure, George's letters to Monroe were doleful and plaintive, full of pathos and dreams and much yearning, but said little about concrete activities and accomplishments. Some of them are so nostalgic for the time they were together that their whining tone is clearly audible. Sometimes he would include in his letters nude snapshots of himself, probably taken by Wesson Bull. Most times he is photographed outdoors either in Englewood or North Egremont. Though he knew Monroe briefly, George already perceived in him the tendency to idealize or to mythify his lovers: "Write me my Monie, of positive things which will give me a feeling of contact with you, and a sense of you holding me so tight and so tenderly in your arms again. Little things to remember are always so sweet. And there are so many little things to remember in you. I wish that you would not be so determined about sticking me into a myth, for I can see that I am going to have a hard enough time to keep from becoming one . . . But, so often, myths grow so impersonal and cold! I suppose it would be very well if I attempted to become a 'man of letters'; I think I should like it. One cannot always be a plaything for the gods. Write to me. How does one set about all this? Monie dear, I love you so. gpl." But Monroe knew something about writers and did not want to discourage George's youthful idealism, though he was fully aware that in order to achieve such a dream it would require dogged persistence, patience, and much discipline, qualities that in his view, George lacked. Unable to worship him as a living

success or as a Greek demi-god with attending myths but still full of love and sensing George's unidentifiable potential, Monroe, in a true Cocteau fashion, decided to shape and polish this diamond in the rough, a role he played several times in his life. He began not by talking George out of becoming a writer; he knew full well this was not going to happen. Being a natural born teacher, Monroe began by writing George extraordinary, if not inspirational letters and post cards, all relating fact to senses; color to pitch and form; people to their outstanding accomplishments; "connect, connect, connect." Often the letters contained photographs and many newspaper clippings; post cards bore brief lines that captured the essence of a masterpiece, a sentence that enabled one to smell the garden being described. Such personal touches were often supplemented by inspirational quotes and words of encouragement, as well as by forceful suggestions that George keep a diary and either a commonplace notebook or a book of aphorisms reflective of one's philosophy of life. Monroe sought to create an individual much like himself or like Raymond Mortimer, a fascinating homosexual who, having developed his God-given talents, was a great lover, a superb raconteur, an indispensable traveling companion, and a welcome guest in straight society. Not having any illusions about love lasting forever, Monroe conceived an ideal homosexual as "a male courtesan," not as a prostitute as the term has come to mean, but as a highly educated and socially refined individual who might attract the association of well-educated men of rank and wealth, as did some distinguished females in seventeenth- and eighteenth-century France. In Western literature these types of men occur in a slightly disguised fashion as heroes of Stendhal's *The Red and the Black* (1831), Colette's *Chérie* (1920), and Constant's *Adolphe* (1816). On March 18, 1927, Monroe sent George Benjamin Constant's *Adolphe*. The education of George Platt Lynes had begun. This marked the beginning of Monroe's serious interest in and Glenway's acceptance of George Platt Lynes.

With the help of his family and Edith Finch, George opened in October 1927 The Park Place Bookshop, not in New York as he had hoped, but in Englewood, New

Jersey, scarcely a mile from his father's rectory. It prospered, with its principal best sellers being Glenway's *The Grandmothers*, Thornton Wilder's *The Bridge of San Luis Rey*, and a scandalous book named *The President's Daughter* about a presumed tryst of the recently deceased President Harding. In the shop a Man Ray photograph of Gertrude Stein was prominently displayed. By the end of January of 1928, George wrote: "The book business is not exactly satisfying. The urge seems to lead else-where.... Existence here is like no existence at all. It is so beautifully true. Nothing ever quite happens." In March of 1928 George sold The Park Place Bookshop, paid back his parents and investors, and bought a passage for Europe. "I am headed, so I am told, for a land of wasps and primroses." After a two-day stay in Paris, he arrived in Villefranche-sur-Mer at the end of April. He stayed in France for nearly a year.

For George, entering Monroe's and Glenway's Riviera life was like stepping into a fantasy world populated with "remarkable people doing remarkable things; it's a ravishing place. I couldn't begin to describe its beauty and the people I've seen here: gardens, deathly casinos and dowagers weighed down with pearls and emer-alds, somebody's cousins from Idaho, nobody's cousins from the great beyond. It is very impressive indeed. I adore it ... " The enchantment would continue, because less than one week after his arrival Monroe took George on a four-day excursion to Corsica, to "Erbalunga, Bastia, Piana and Ajaccio ... where there were mountains and brigands and dust and fleas." It was an isolated time of sharing, both physically and mentally; it confirmed that their meeting in New York was not just a one-night stand. Monroe's affections grew in intensity proportionately to the time they spent together. They returned to Nice by boat directly from Ajaccio. It was a smooth, pleas-ant passage, except for the presence on the boat of young Sir Francis Rose, the "local bore," in Monroe's words, "whom we ran into in Ajaccio, and who insisted upon sit-ting with us." Aside from its obvious sexual importance, this honeymoon-like trip is noteworthy because it is the first documented instance of George taking pho-tographs. All of the extant images of Monroe on this trip were taken by George with Monroe's folding Kodak. After this trip Monroe began calling George "Giorgio."

For the rest of that spring and summer, Monroe made sure "Giorgio" would meet his friends and, together, they explored the Riviera. Mary Butts took an instant shine to George. She also shared his dislike of Francis Rose, whose behavior she disapproved and tried to help him overcome. But rather than thank his fellow compatriot for her care, he sent her "four pages [of] pink lavatory paper of abuse," and had the impudence to write her "an insolent letter about Cocteau," her close friend and admirer. She also kept at the foot of her bed a photograph of George taken by Monroe, telling George that everyone inquired as to who it was and made remarks about his personal appearance. She would always answer, "Wait till you've seen the original." Once George asked her to inscribe one of her books to him. In it, according to his brother Russell, she wrote:

> "Would you like to sin
> With Eleanor Glynn
> On a leopard skin?
>
> Or would you prefer
> To err
> With her
> On some other fur?"

Mary Reynolds also adored "Giorgio," and spent a great deal of time with Monroe and Glenway while he was there. Later, when she was in New York during World War II, she resumed her friendship with him, much to his satisfaction. Of course George met Bérard, Bourgoint, Desbordes, and Cocteau, who was to draw him that fall. There were such new friends as Clemence Randolph, Kate Lawson, Dick Halliday, Eardly Knollys, and Hugh Brook, and an occasional old one, such as Wesson Bull, who turned up at the Hôtel Welcome and spent the autumn (plates 29, 52, 56, 60).

To himself, his parents, and Monroe, George justified this sojourn in France with the determined intention to write a novel. Especially with regards to Monroe, he had the disquieting feeling that he had to produce something to impress him. It was beginning to be clear to him that, in the long run, sex alone would not hold Monroe's love and devotion. Soon enough this pressure became quite self-evident, especially since Monroe would always introduce him as a young novelist and, invariably, his interesting friends would ask him if they could see something he had done. After the initial trips and sociabilities, he rented a little studio in a quiet part of Villefranche and sat down to the task. But after a few months of trying, even after Glenway found for him yet another secluded place in San Martin Visubi, a mountain town in the lower Alps directly behind and above Nice, he destroyed a text of twenty-five thousand words without ever showing any of it to either Glenway or Monroe. He soon developed a combination of melancholy, loneliness, and "mysticism," which to him meant fantasy and fanaticism.

It was at this time that George began to comprehend the extent and nature of Glenway's devotion to Monroe. He realized that, like in his own case, Monroe drove Glenway's productivity, including his determination to create better and better stories; his concentration; and his discipline, which was tinged with anger. It seemed to George that Glenway lived for Monroe, a realization that brought him closer to Glenway by way of identification. But George lacked Glenway's dedication, and unlike Glenway, who mined his homosexuality as a literary prime mover, George had not enough fire in his belly to drive his writing, something he did to please Monroe. Glenway was beginning to understand this and cared about George's desperation. He may have even enjoyed a certain power over George as he began to help him and, in the process, accept him into his own life.

While George was trying to find his literary voice, Glenway was working at sustaining the success he had achieved with *The Grandmothers* by busily working on a collection of short stories that would come out later that year under the name of

Goodbye Wisconsin (1928) and on various contributions to magazines and journals. He also had a selection included in *The Best Short Stories of 1928*. *Goodbye Wisconsin* was very well received. That summer Glenway met W. Somerset Maugham, who lived in nearby Cap Ferrat, and Thornton Wilder, who was visiting the Riviera after having just won the Pulitzer Prize for his second novel, *The Bridge of San Luis Rey* (plate 83). While his friendship with Maugham would not flourish until much later when Glenway was back in the United States, his meeting with Wilder fructified instantly. "I think it can be said he took a real lively interest in me and in what might be expected of me as a writer. It thrilled me to make his acquaintance." Although they were much alike in many ways, Wilder was a homosexual who was totally and absolutely committed to the closet and lived in mortal fear of ever being publicly accused of such tendencies.

Eardly Knollys, 1928.

Later that summer, something happened that would bring Glenway and George closer together. Apparently Monroe's infatuation with Eardly Knollys was not over when he came to visit them in Villefranche that summer. Introduced to Monroe by Raymond Mortimer in London, Knollys was a quiet, tall, and attractive twenty-six-year-old Englishman who had studied art but, for the last two years had been trying his luck in Hollywood. A great admirer of French art, particularly that of Renoir, he later opened a well-known art gallery in London. After a decade, he gave up the gallery and began painting exquisite colorful landscapes that bordered on the abstract and which achieved great success. Sensing Monroe's interest in Knollys, George decided to make him jealous by having an open and silly affair with Hugh Brook, another guest. Rather than getting him back, the strategy backfired, angering Monroe, who did not anger easily (plates 56–58). George and Monroe became somewhat estranged until

November when together with Glenway they went to Paris. As Glenway and Monroe had done in response to Elly Ney, George and Monroe reached some sort of accommodation, so much so that in early October George felt free enough to make plans with Glenway, as Cocteau had often done with Bourgoint and Desbordes, "to go to Toulon for the night . . . to see the sailor parlors. It is a most immoral town."

When they arrived in Paris, all three stayed together in Jean Guérin's apartment until he returned from London, which turned out to be sooner than expected. Monroe and Glenway found a place on the rue des Eaux and George moved to the Hôtel Nice on the rue des Beaux Arts. In Paris they continued meeting such mutual friends as Butts and Reynolds, often eating at Le Boeuf sur le Toit, as well as going to concerts, the theater, and the ballet. In those days George was often seen in the company of Wesson Bull and René Crevel, and he had reestablished his contact with Gertrude Stein. By Christmas, it appears that Monroe and "Giorgio" were close again and now the three men and a friend were spending a lot of time together, especially when it came to musical concerts and ballet. The friend was Jacques Guérin, and he and Glenway were beginning a relationship that lasted well into 1933.

"Christmas was spent with Bernardine Szold," Monroe wrote to his father in the waning days of 1928: "[Bernardine] returned on Monday from her trip around the world with Barbara Harrison. Barbara has given Bernardine her two houses here for the winter, servants and all—a beautiful house on Vaugirard, and a country place at Rambouillet, outside Paris." Bernardine Szold's introduction of Barbara Harrison to Glenway and Monroe had a profound determination upon their lives as well as upon George Platt Lynes's.

A New Yorker by birth, Barbara Harrison was the daughter of Francis Burton Harrison, a congressman who gave his name to the pioneering pure food and drug Harrison Act, as well as the governor-general of the Philippines under President Woodrow Wilson, and Virginia Crocker, a railroad and banking heiress from California. Her father's forebears, an old Virginia family, traced its family ties

to Thomas Jefferson, a man who believed in higher education for women. After three years at Oxford, "where women had to work exceptionally hard," she left for Paris in 1925. It was the era of the American expatriates and she, too, met Stein and Hemingway and those who were members of Stein's circle such as Tchelitchew and Szold, among others.

In mid-March of 1929, Glenway and Monroe left on a much-anticipated trip to Spain and Morocco, but before departing, Monroe went to see George and they made love as if they had just met. Soon after "Giorgio" wrote Monroe: "Your image lies on my heart, firm and without oppression, like your kisses on my mouth. The fragrance of your body haunts me; I am saturated with it. I have no need at present for the luxury of love. Thank God for that; I can wait until we meet again." No sooner did he arrive in Englewood than he suffered a ruptured appendix and was operated upon. At the time less than one percent survived peritonitis. In response to a tender and loving get well letter from Monroe, George wrote: "Most precious Monie . . . The worst is over. I am thankful I even shudder a little when I think of the danger I was in . . . For two or three months now I will have to sit about. I can read and write, but all exercise, even driving a car, is forbidden me. Can I be a fatalist and say that I was spared for some definite reason? That I was taken ill because I was never meant either to take the job father had planned for me or to sell Christmas cards? But what? I suppose I will try to write stories. But all I want in the world, the old story, is to be with you again. I would give everything to be with you now, no matter where, as long as I could touch and smell and talk to you." On June 28, Monroe and Glenway arrived in New York on the *President Harding* and were met by Lloyd Wescott, Glenway's younger brother, who motored them in Reverend Lynes's car directly to Englewood, New Jersey. After spending two weeks with the Lynes, Monroe and Glenway departed for the Midwest to visit their families.

When Monroe and Glenway returned from the Midwest in late July, they were invited to stay at Englewood, from where they often visited their friends in

New York City. That summer they saw mostly Frances Robbins, Kate Lawson, Hope and Walter Weil, Dick Halliday, Willy von Hoogstraten and Elly Ney, and a great deal of Lloyd Wescott. Monroe wrote his family: "Elly, by the way, is playing in Chicago about the 15th of October—do let Richard hear her. I learned the 'last straw' in her relation to her Chicago husband, Paul Allais,—he made her pay $15 a day board while she was living with him in Chicago!" But to all the friends, this summer was best remembered, in retrospect, as the time when George Lynes, still somewhat uncertain about his future, decided to become a photographer. One might say it happened quite by accident. One evening that early August, his parents and Richard being away in Europe, George was entertaining Monroe and Glenway for dinner. After dinner George brought out his collection of photographs, portrait albums of family members and friends, as well as his collection of male nudes, including some European photographs and the latest takes of Tony Sansone he acquired directly from him (plates 40–41). There were also professional portraits of Monroe and Glenway as well as the more informal ones taken with Monroe's folding Kodak, including one of Cocteau with the long looking glass and one of Stein wearing a tiger skin fur hat (plates 48, 89). What was instantly evident to both Monroe and Glenway was George's ability, even in these snapshots, to capture and reveal a certain quality in the subject that was always there but not always apparent. When they suggested he take up photography, George decided to try it. Before Monroe and Glenway returned to Europe in mid-September, they made arrangements with Hope Weil for George to borrow her equipment and get some pointers.

In a letter dated September 20, 1929, George wrote Monroe: "Lover... This week, since your departure, has not seemed too bad. When I cannot have you, I like to be alone, and what Siegfried [?] calls 'the struggle towards orientation' is not distressing.... When I am not writing, I am reading and, of course I see people. Yesterday I called on the Weils. They were both charming to me, and went to no end of trouble to hunt up and drag out the collection of photographic equipment and literature. Monday she [Hope] is going to take me to the Eastman place, and later on,

when I get back from the Berkshires at the end of the week, we are going to take pictures together in her drawing room. I'll be tremendously pleased if she is interested and takes me seriously." Hope had given up photography and become a bookbinder, thus George got her five-by-seven view camera, a plate holder, a tripod, and some simple spotlights. There was basic darkroom equipment as well. He also persuaded a local portrait photographer in Englewood, a man named van Walven, to teach him basic lighting techniques, how to gauge exposures without a light meter (a task at which he quickly became extremely accurate), and how to develop film and make prints. His first subjects were his brother Russell and Lloyd Wescott. Rather than shoot nature, George preferred to photograph people. He turned the rectory's guest bathroom into a darkroom and made proofs with printing-out paper he exposed to the sun, producing reddish, fugitive prints. In early November he wrote this to Glenway: "I am not unhappy; it [photography] is infinitely subtler. Neither am I dissatisfied. The work is interesting. I have taken dozens of pictures of which three were presentable, one above average. I dislike the acid under my fingernails, enough to be unwilling to go on doing shopwork forever, but hope for better days is still too strong in me to doubt the end of it all." One month later, On December 6, 1929, he wrote Monroe: "I really believe I am working more for the perfection of our relationship than for any other single thing, and that in itself makes me glad for the opportunities of this separation. I have taken dozens of pictures; I am proud of some. Now I am going to have certain ones enlarged which I shall send you. . . . This week I have taken Max, Zena, Demetrios Vilan (a dancer), and Paul Meeres (also a dancer). Meeres, as you probably know, is Negro, a cafe-au-lait-ish one, and the most beautiful man I have ever seen. Slighter than Sansone, but finer, subtler, and more plastic. Those were nudes and near nudes. In any case, a set for you. . . . Last night I dined with Kate and we both went afterwards to Hope's." Not two weeks later George wrote: "Elsewhere I have said that each batch of plates was better than the batch before. In a measure that is still true, though less apparent. I have learned to overcome the major difficulties, what I suppose to be the major ones, and now am

working on the little things. It all requires much patience, and I have not a patient nature. . . . If ever I am [to be] a successful photographer, that exuberance and fantasy, equalities of that order, will be the making of me, rather than calculation and impassivity." In mid-spring George wrote Gertrude Stein: "I have a chance of becoming a good photographer."

George's growth as a photographer had an impact not only upon his own nature but also a direct and measurable effect upon how he viewed his relationship with Monroe. "There is peace here," wrote George to Monroe in October. "The days are warm and the nights cold. The air is delicious. And I miss you. Never, dearest, has separation from you been so intimate and melancholy. Never have I thought of you so continually, so tenderly, with so pure a resolution. And I am sure it was only the misery I permitted myself on other occasions that has kept me from recognizing fully the strength you have increased in me. I cannot explain, save by steadfastness, yet now every nuance of your body, all the delicacy of your thought — your image in all details is before me, moment to moment. And I love you. I do not mean to let you go. . . . This solitude is doing something to me, giving me something, and every thought of you is lustrous. It really does mean infinitely more to me to have you be sure of me, than it would to know you were wholly, wholly in part, mine . . . At present I am quite sexless, a state of affairs which astonishes and delights me. Desire is intellectual; life here is too benumbing to permit sensation. I am doubly astonished that all the beautiful people, clothed and unclothed, I have photographed affect me no more than if they did not exist . . . the advantage of using up one's surplus energy. . . . And when I dream at all it is of you." For his part, as was his curious nature, Monroe not only continued to encourage George's interest in photography but became totally involved in the process. Glenway, mindful of the fragility of a budding talent, nurtured him along with every new batch of photographs he received, carefully commenting on every image.

Upon their return to Paris late in September of 1929, Monroe and Glenway temporarily moved into Barbara's house on the rue Vaugirard. There they resumed their

social activities by frequently receiving the writer Julian Green, attending concerts and the theater, taking motor trips with the Cottonets who were then in Paris, and spending weekends at Rambouillet. Located in a Paris suburb with the same name, Rambouillet was also the name of Barbara Harrison's country house, which consisted of three small houses decorated with seventeenth-century French furniture, Aubusson carpets, and pictures by important contemporary artists. The living room was extremely large, "the largest I've seen in a private house: all in white plaster and dark woodwork and hung with Courbets and Gauguins. The dining room is hung with Picassos and Derains." Rambouillet also had a splendid garden. Glenway's novel *The Pilgrim Hawk* is set in this house, and he describes it in great detail. When he was at his country residence, the president of France was an immediate neighbor.

As their friendship grew, Barbara's fondness for Monroe—this brilliant, sensitive and unemployed man—gradually intensified. It was at one of these Rambouillet weekends that she decided, even as the New York stock market was crashing, to finance a press that made exquisite, deluxe limited edition books. Bearing her name, the press was called Harrison of Paris. Whatever the motives that led to its existence, the press eventually brought fame and immortality to her family name, gave expression to one of the great book designers of the twentieth century, and, in the process, netted a superb editor, Glenway. Also, unlike Elly Ney, who was willing to risk everything for a conventional setup with Monroe, Barbara was an infinitely wise woman, and she created a situation that was acceptable to everyone and that also allowed her to have Monroe by her side. With Glenway in a now-committed relationship with Jacques Guérin and Monroe's difficulties with George apparent, her present setup may have not been ideal, but it certainly worked for her.

Those who have written about Harrison of Paris and not read Barbara Harrison's letters or known her personally often portray Barbara as an absent, manipulated, rich heiress, who left all decisions to Monroe. Nothing could be further from the truth. In fact, all decisions were arrived at by consensus and involved all three "partners," that is, Barbara, Monroe, and Glenway, with Barbara having the final say. All three contributed suggestions on the selections to be printed. To Monroe

went the task related to all matters of book design and production, the choice of the best European printers and binders, the selection of "the most brilliant draughtsmen available" to illustrate the books, and all matters of distribution. In addition to being part of the "selection committee," Glenway made a significant contribution as editor.

Despite his fears and imagined threats to his relationship with Monroe, some of which were fanned by Glenway, George continued to work hard at his photography, write loving letters to Monroe, and dream of summer when he would be in Paris. In April, he had a modest portrait photography show, his first ever, in Englewood's The Park Place Book Shop. It was on view from April 21 through May 3, 1930. The invitation to the show noted that sittings were by appointment. In response to Monroe's letters of praise and encouragement, George wrote: "I think some of my pictures are good, or, to put it differently, the more pictures I take the less I am impressed by those taken by others. I am often aware of the fact that I am the only photographer (I know anything about) who has no method, no style or pretense of one. I've certainly no doctrine about it. I should like to develop a style, or rather about six styles a year, but think it unlikely that I will at present. Principally that I have been and will be taking pictures professionally with amateurish equipment . . . an unreliable lens and inadequate lights. The camera I am devoted to, and might in time purchase its duplicate. I would give a lot to have a properly equipped darkroom this summer, but if I had that I should have no reason probably for returning here this fall. I have prospects for about six sittings before Xmas. I am greedy. I want to establish myself in Paris this summer and perhaps come back here for a couple of months (October to December) for the 'rush.' It might be arranged, and yet . . . I wonder how much recrimination there would be at home."

George arrived in Paris at the end of May, having paid for the trip with the sale of a rare book from a withdrawn edition of Huckleberry Finn he had found among his father's old books. Soon after his arrival, George found a tiny apartment, four flights up, on 16, rue Granariere, not far from Monroe's and Glenway's new

apartment on 9, rue de Conde, in the sixth arrondissement. "A living room which I will use exclusively for photography, a kitchen which I am transforming into a darkroom, a bathroom and a bedroom. Very comfortable, though badly decorated, and all for $40 a month." George's presence in Paris immediately rekindled Monroe's sexual ardor, and soon they were going away together to "charming medieval towns," and to the opera, *The Magic Flute*, a perfect opera . . . surely the only opera I have ever heard in which there is no dull moment. And divinely sung by Lotte Schoene." That summer George photographed the actor Alexandre Kirkland (who delayed his return to America by a day in order to see proofs), Julian Green, Ludwig Lewisohn, and Paul Morrand, among others. "I have tentative engagements to photograph [Constantin] Brancusi and Ford Madox Ford. There will be others." He also photographed André Gide, who had a crush on him, and Jacques Guérin. It was Glenway and Monroe who introduced George to many of the artists and writers he photographed; others he met at Stein's studio in the nearby rue de Fleurus. It was obvious to him that the way to make a name for himself as a photographer of the sort he intended to be was to photograph men and women with established reputations in the arts and letters. In those days of precommissioned portraits, George was collecting faces with names for what he hoped would someday be a "celebrity exhibition."

The first four titles brought out by Harrison of Paris appeared in the fall of 1930. The first publication — *Venus and Adonis* — an abandoned masterpiece by Shakespeare, was strongly urged by Glenway, who created the fused letters V and A that appear on its cover. The second publication was Bret Harte's *The Wild West*, which contained eight watercolor drawings by a young French artist named Pierre Falké. It was a collection of seven tales celebrating the West, "America's most magical, historical and legendary setting." They decided to publish Harte, the West's spokesman and laureate "to whom countless cowboys with Greek profiles, maidenly sturdy heroines and poetical platitudinous films, famous world over, owed their existence, but whose popular editions, printed on very inferior paper, amounted to premature

extinction. Harrison of Paris wants to repair this damage by turning out a volume technically worthy of him." Monroe selected a large eleven-point Bodoni type, a sturdy vellum paper, and for the cover, a rough Hessian cloth that was coarse to the touch and suggestive of Western garb. This was followed by Thomas Mann's *A Sketch of My Life*, an autobiographical overview of his life up to 1929, and Glenway's *The Babe's Bed*, also autobiographical and dedicated to Barbara Harrison.

With the 1930 publication of *The Babe's Bed*, Glenway closed an introspective cycle that began with *The Apple of the Eye* (1924), and continued with increasing intensity in *Like a Lover* (1926), *The Grandmothers* (1927), and *Goodbye Wisconsin* (1928). It is clear from all these works written abroad but set in Wisconsin that Glenway was more concerned with rendering a state of mind than he was with creating the place itself. In them Wisconsin is the Midwest, and the Midwest is a metaphor for the America from which Glenway physically escaped, bound as he was by its psychological and emotional effects. Central characters such as Dave Strane in *Apple* and Alwyn Tower in *Grandmothers* are versions of himself, a homosexual who examines himself in the context of his family's legendary past and events in his own life; of difficulties with his father that forced him to leave home at age thirteen; of a suicide attempt at age eighteen (at which time he was engaged to be married to Kathleen Foster); of his meeting Monroe and falling in love with him; of his withdrawal from college; of the Elly Ney adjustment or compromise; and of the European experience. In a critical assessment of Glenway's oeuvre, Bruce Bawer points out that Glenway's covert, unacknowledged homosexuality is really the central focus of his stories and novels, "something of great consequence being dealt with but never explicitly acknowledged." With the eventual incorporation of George Platt Lynes into his and Monroe's lives, nowhere is this last topic treated with greater elegance than in the subtle triangularity underlying his most refined achievement, *The Pilgrim Hawk*. One can only wonder, given his extraordinary power and range for lyrical prose, what he might have achieved, had he felt no constraint, had society permitted him to express himself freely and openly, without fear of scorn and

rejection, about "the love that dare not speak its name." His kind of sustained dedication to the truthful and dogged pursuit of a single theme, homosexuality—this unspeakable but natural subject—had never before, nor since, been so thoroughly and systematically examined in American literature. The *Paris Herald* called *The Babe's Bed*, "really inspiring" and "far superior to anything" Glenway had written so far.

Monroe made arrangements for his and George's passage to New York on the *President Roosevelt*, which sailed on September 25, 1930. Less than two weeks after his arrival, Monroe had a gallbladder attack, was operated on, and taken to Englewood to recover under George's loving care. Travel as far as Evanston was forbidden for Monroe. This not only frustrated and made Glenway feel at a distance and completely impotent; in his desperation to be with Monroe in his hour of need, he poured out his affection to George, demanding of him that George do what he himself would have done had he been there. In the process a great deal of their triangular relationship was revealed. After the worst was over and Monroe was able to go on to Evanston, Glenway wrote George: "Georgiemostdear, In horrid haste: Monroe asked me, by wire, to send him cards to put in gifts he apparently found time to get for my family. In the calamitous five-day reign of the great Ney, I didn't even find time to do so. Now I am afraid to send them to Evanston lest he have already started back in your direction, etc. So will you, according to his motions, get them to him as quickly as possible. Ought he to sail as soon as the 15th? Vera informs me that he lately weighed only 108 pounds. Won't he, as soon as he gets here, start running up and down after printers, etc.? And I haven't even a fattening cock yet, not having found time to make the shift—or is it energy that I lacked?—Scarcely. Any way please bear this in mind, and if there is any question of its being better for him to stay over there a bit longer, and he, in receipt of some maddened letter of mine, thinks he oughtn't to leave me to my own fantastic devices, resources any longer — why, speak in my behalf as well as your own. I want him to be well; nothing else is of permanent importance, and I mean NOTHING. Though life is a sort of optical

illusion without him. You aren't old enough and over-enriched and over-developed enough yet to need him that badly. Which isn't an insolent saying, dear. Whenever I have energy to wish things, or time to shed a tear, I desperately want you to come back with him — not for his sake or somebody else's merely — for my own. Dearest friend . . . Glenway." In another letter two weeks later Glenway expresses a desire, a sentiment. "It consists principally of wishing, oh so ardently and heavy-heartedly, that you were coming back with Monie. There isn't anybody or any sort of thing to take your place for me. So many atmospheres and attitudes and sequences of almost imperceptible gestures that, described, sound like flattery or dependence or softness or mere habit have come more and more to be certainly the rarest sort of affection. I haven't any idea, of course, what you and Monie latterly have been learning, amid the anguish and the abnormality, about the penalties of your relation: how he impedes your development in the matter of aggressiveness and independence and mask-wearing and disinterested or extra-amorous enthusiasm and fruitful temperateness of climate, and how your vine-like net-like tenderness sometimes exasperates or binds or trips him up. . . . I suppose there are always shooting-pain penalties where love runs through the nerves, the charnel nerves. Anyway, aside from that, more and more every year, thinking of myself alone, myself-without-anything-or-anybody-but-M., it seems undesirable that we should live apart. At the moment that almost seems to mean undesirable that I (and we) should live here — for I am going to go on being homesick and sick of my French life until I have built up much thicker about me a whole hallucination — America of the Clevelands and Co." Monroe returned to Europe before Christmas and as soon as he arrived in Paris, Barbara whisked him to Caux, Switzerland, for a quiet period of convalescence.

The winter of 1930 and 1931 was difficult in the United States: breadlines and apple sellers on street corners, soup kitchens and cardboard villages in public parks. It was a winter of evictions and bank failures and six million unemployed, and George, as the young tend to be in serious times of crisis, was seemingly unperturbed, surviving

with the help of his family and an occasional portrait commission. "How I loathe making school girls beautifully vague," he wrote Stein just before Christmas. "But there are still people who are beautifully natural or simply beautiful, and I find comfort in that. . . . The vanity of young Americans is just compensation for the vanity of their parents, their aunts, and their living ancestors. And there are conservative politicians, actresses, and men of letters. It rather suits me, however; I do not wither, but otherwise resemble an old woman . . . guarding my memories. God bless us." His escape from the parson's house to New York was as frequent as he could make it. There, he would meet John McAndrew, a young architect who would soon become the "secretary" at Julien Levy's gallery at 602 Madison Avenue when that small but influential showcase for surrealists and photographers was just beginning to attract attention (plates 98, 102). Also, there was Philip Johnson, the architect who was to become the first director of the Museum of Modern Art's Department of Architecture, and who introduced him to Edward M. Warburg, Eliza Parkinson, and James Sweeney, the other members of the Junior Advisory Committee of the Museum of Modern Art. There was also Lincoln Kirstein, his friend from Berkshire days, and those pertaining to Muriel Draper's circle. But the person who worked tirelessly to help George was Miss Fanny Cottonet. She arranged for sitters, extended frequent opera invitations, and introduced him to painter and well-known gallery owner H. T. Leggett for the purpose of arranging a well-publicized portrait exhibition.

In 1931, George wrote Monroe: "I am now a collector. Julien [Levy] has given me twelve [Eugène] Atgets in exchange for some of my pictures; they are very charming, and some of them really excellent. And I am, of course, being collected. Besides those Julien has, and those I have given to John [McAndrew], I have sold two prints: one of a gas stove in a warehouse doorway, and one of my Amenophes. All these and more you will see this spring when we meet. Some of the work I have been doing must be good. I feel, in any case, that both Julien and Joella (Mina Loy's beautiful daughter) are very critical. And both are enthusiastic. I also value John's

opinion . . . he seems to me to be more intelligent than most of the people I meet . . . although for reason or reasons unknown he seems prejudiced in my favour."

While George was excitedly preparing for two upcoming fall exhibitions and the imminent summer trip to Paris, the Harrison of Paris partners were busy preparing the next four books: Sir Roger L'Estrange's translation of *Fables of Aesop*, Prosper Mérimée's *Carmen and Letters from Spain*, Madame de LaFayette's *Death of Madam*, and Dostoevsky's *A Gentle Spirit*. Things were going so well at first that they decided on a fifth title, Byron's *Childe Harold's Pilgrimage*.

Barbara's involvement in the bookmaking process can be clearly understood from the following memo, written quickly in pencil, to Monroe: "I have ventured to make a sketch illustrating or trying to correct some of the points I'm quarrelling about. I noticed that in the page you sent me the large *CARMEN* was included within the space given (on the other pages) to text type. But I have put *CARMEN* (on my page) above the text-space—almost as though it were a running head, though of course I don't propose that it should be used throughout the book as a running head#!...By the way, speaking of page numbers, Glenway tells me that you thought of numbering the *Aesop's Fables* pages on the inside corners (near the center of the book). Is this so? And if so, don't you think that they will be quite useless to any-body wanting to look for page number so and so. If we have no index then we don't need page numbers at all, and if we do have an index I think they ought to be where people can find them without opening the book wide at every page."

Fables of Aesop turned out to be one of the most remarkable, attractive, and entertaining volumes the press ever produced. The entire book has been described as "conveying a sense of antiquity: the desperate mysticism of Aesop's primitive Greek mind, the outbursts of the rough and sparkling genius of the witty Elizabethan translation," and the paper itself, hand-made pure-rag paper from Auvergne which was still being made, "just as in 1326, the pulp beaten by water-driven hammers in stone vats, the great sheets as soft as old handkerchiefs, dried in

the open air." The paper felt coarse to the touch but its texture was uniform and smooth, with slightly irregular and ragged edges. Louis XIV wrote his memoirs on Auvergne, and it had served for the first editions of Molière. The covers of the book, of soft pale blue, possessed the same smooth yet coarse texture of the pages, and were made from discarded blue aprons worn for years by the Auvergne school-children. But it was the fifty modern, wirelike drawings by Alexander Calder — audacious and revelatory — that provided an even more explosive and expressive contrast. Delicate and never perverse, alongside Aesop's quiet humor the images are somewhat bittersweet and often show the timeless and universal pathos of human behavior. An impressed Leo Stein was moved to comment that Calder's illustrations were "more complete and satisfying than Picasso's." As Hugh Ford noted, "It was a book in which the physical, the aesthetic, and the philosophic could hardly have been more felicitously blended."

The final, and "most problematic," Harrison book of 1931, was Byron's *Child Harold's Pilgrimage*. The challenge lay in placing the poet's marginal notes and sudden changes of thought on the same page with the text without causing crowding or a look of overabundance. Monroe's solution was an amiable blending of space and the printed word by using twelve-point Didot roman type for Byron's text and nine-point Didot italics for the notes on an 8 x 9-inch page. The choice of the English painter Sir Francis Rose, another friend of the partners, for the illustrations further underscored Harrison's reputation as a press dedicated to the work of young artists. Rose's twenty-eight wash drawings printed in collotype by Daniel Jacomet marked the artist's first appearance in book form. Despite the obvious riches of the Byron volume, including the binding by Huser, the best-known binder in Paris, the book sold poorly.

The 1931 offerings by Harrison of Paris received the applause of critics on both sides of the Atlantic. The *London Times* referred to *A Gentle Spirit* as "an extremely elegant piece of book production. It is a pleasure to contemplate the pages." And the *New Yorker* called Harrison's publications "the best of the year's

issue" and added that "for papers, print, and price, they are extraordinary as collector's items in any land."

Monroe and Barbara were happy at Caux. As his health improved, they were able to spend more time outdoors, enjoying the ideal wintry landscape. Photographs at that time, often used to illustrate articles and books on Harrison of Paris, show them laughing and holding hands as they skated in the snow (plate 135). Upon their return to Paris, they immediately resumed work, but, gradually, Monroe fell into a melancholic slump, a state of sadness and negativism that began to deeply concern those around him, especially Glenway and Barbara. One thing Barbara did was to send George an open round trip ticket to France. She also took Monroe to London, where he claimed to have more friends than in Paris.

What both Glenway and George suspected but neither one dared to voice was that Monroe's devotion to Harrison of Paris and his complicated relationship with Barbara was boxing him in with no visible signs of a possible escape. Even affectionate letters from George could not shake him out of his morass.

George's arrival in Paris that summer had a calming effect on Monroe, a fact that did not escape the observations of either Barbara or Glenway. Busy as they were with preparing the Harrison of Paris publications, George settled in the apartment Jacques Guérin lent him and proceeded to get busy by making photographic advertisements for Guérin's Perfum d'Orsay and taking portraits of children and businessmen. Except for breakfast, he took his meals at rue de Conde. As it turned out, his most important photographic assignment that summer was a visit to Gertrude and Alice in Bilignin, where he ended up photographing them outdoors rather than indoors as he had wished. While Gertrude was delighted with the photographs, George was not pleased. They saw each other again back in Paris in July, a time George also saw Cocteau, Bourgoint, Bérard, and Desbordes. Mary Reynolds and Aaron Copland would often came to lunch with George. At that time Copland, whom George had met at Muriel Draper's, was in Paris studying with Nadia Boulanger.

In early August, when most of the Harrison of Paris work prior to distribution had been completed, Barbara invited Glenway, Monroe, and George on an excursion to parts of Austria and Germany in her huge secondhand Renault driven by Barbara's chauffeur. They went to Salzburg for a week of opera, stopped in Colmar to see Grünewald's *Crucifixion,* and looked at baroque and rococo churches in Bavaria. They also spent a few days in Vienna. In Frankfurt Barbara made George a present of a three-year-old dachshund, only two-thirds the size of an ordinary dachshund. "He is really a beautiful creature and I am tremendously attached to him," George wrote. "He is beautifully marked, beautifully silky, beautifully friendly (and not in the least sentimental) and deliciously playful. His name is Claus von Wiesbaden. He has a pedigree ten miles long, and sixteen quarters of nobility . . . " Having accumulated a good number of distinguished faces for a "celebrity exhibition," two of which were tentatively planned for that fall, George sailed back to America on October 8. On the day of his departure, Glenway handed George a hand-written letter he wrote before going to bed: "Au revoir, Georgie. Perhaps Monie hasn't enough imagination to know, or is too fearful of his extreme sensibility to let you know, how much we both are going to miss you. Thank you for having come, thank you in advance for coming back. It seems to me that you rescued me this summer, taught me a lesson of what was there still when something else wasn't, brought me to my senses, rewarded me for some sort of fidelity in my contradictions that no one else saw (and by more than the one remedy, though I also bless that one). And it seems that there is something new in myself, in my experience, made to last — an imperturbability — Can it be?"

As soon as George arrived in New York he took a flat where he could photograph and, occasionally, entertain. He was sharing it with John McAndrew and Lloyd Wescott. "The flat is agreeable. I think I gave you the address: 425 East Fifty-first. We have a fair-sized room and a smaller one, five big closets, a kitchen, and bath. The larger room Lloyd has painted grey, and I do not object, the smaller room John

has painted cinnamon, which I do not admire, but that has nothing to do with me. They bought furniture together: the sodafountain variety, wire and marble tables, wire chairs with fake cane bottoms, and a garden bench. But I am not going to live there, and these things are props. I only ask that the Edwardian cream-of-tomato tureen is put as much as possible out of sight. You will see for yourself."

The big event in the New York art world that fall was the November 2, 1931, opening of the Julien Levy Gallery on Fifty-seventh and Madison. Two days after the opening, George wrote to Monroe: "We managed to get Julien's gallery open on time, and very well it looks. All last Saturday I helped to frame and hang pictures, and to prepare announcements for the post. I could not get in for the opening on Monday, but dropped in yesterday for a while. I think Julien is cheered, although he does not expect to sell much. About two hundred people came in the first day, and there were lots of amiable press notices. Joella, at the reception desk, is very lovely, but looks like a girl who has never had a job before and does not care if she loses it. And the show is handsome, although there is little in it I would like to own, and less I would like to adopt. The [Alfred] Stieglitz seem undistinguished. And have you ever seen any early [Edward] Steichen? They have a box full of my things to show on occasion. My exposition is to be in February, at the same time as a show of Walker Evans, and somehow the prospect does not terrify me. Will you be here to see it?"

In addition to printing all the pictures he had taken last summer, George had been making pictures for Julien and experimenting with "toning baths," new papers, and new films. "I appear to be learning something. For my part, I have made enlargements of all the pictures of you [Monroe] and of Glen. Yours have not been mounted yet. I took those of Glen (except the three he wished suppressed) and sets of Muriel and of George Davis to *Harper's* the other day and was surprised by the cordiality of Miss Herdman's reception. She apparently liked them all and ordered two poses each of Glen and Muriel. And while I was there Langdon Davies (isn't that his name? I, of course, being illiterate, never heard of him before) came in and was immediately dated up. He comes tomorrow at noon to pose. So that is my first

official job for *Harper's*. Miss Herdman sent me to see the publicity director for Horace Liveright, but I doubt if anything comes of that. When I took Muriel's pictures to give them to her yesterday she was not at home. Two hours later John was giving a cocktail party and not less than six friends of hers, who had just come from her house, fell upon my neck with the wildest and most flattering enthusiasm. Even Max Ewing forgot to be the suave young man about town. And I, who was doubtful about the pictures, was of course delighted. And George Davis likes his. So there you are. I will send your pictures and Glen's as soon as I can get yours mounted . . . within a few days. That may be all I can manage by way of Christmas presents. Each will be numbered on the back, and you can have as many more as you wish.

"Perhaps I wrote that they are trying to make a surrealiste of me. At any rate Chick Austin put *As A Wife Has A Cow* on the cover of the catalogue of his so-called superrealism show at the Hartford Museum, and Julien is putting me in his surrealiste show along with [Max] Ernst, [Salvador] Dali, even [Pablo] Picasso. But, like Picasso, I deny all the implications. And my own show comes later, probably in February."

For the Christmas and New Year's holidays, Glenway, Monroe, and friends went to Florence. Barbara had already left for the Caucasus in mid-December. And George invited John McAndrew, Allen Tanner, Tonio Selwart, Lloyd Wescott, and Russell Lynes to North Egremont, Massachusetts, for a relaxing house party, conversation, and walks in the snow. Tonio Selwart, whom George liked very much, was a young Bavarian actor who was technically the "friend" of Jack Beckett (with whom he lived) (plate 97). During the war, when he was fifteen or sixteen, Tonio was literally in the trenches. Then he studied to become a surgeon, took up acting, married, and had twins who died. He had come to America to act, but of course, due to the Depression, had been idle all winter. George regarded him as a delightful guest — not very entertaining, but well behaved, cheerful and obliging. On that visit he painted Adelaide's summer chairs. He also posed nude for George. Allen Tanner, who was from upstate New York and had given up a good job as an advertising

copywriter to work for Julien Levy, was color blind except that he could recognize red. Wherever he lived, he said, "red art, red curtains, red bedspreads and red carpets surrounded me." He resembled Noel Coward, for whom he was occasionally mistaken, and was personable, generous, amusing, and without pretense. Russell, George's brother, wrote that "no friend of George's was longer lasting or more loyal or, when the final, fatal pinch came, more concerned." After he left the Levy Gallery, Tanner went to work for the Museum of Modern Art, where his tact and enthusiasm made him indispensable. With Iris Barry he established the museum's film library and also wrote its bulletin. John McAndrew, the architect who had worked as Levy's secretary, was a witty man with a lively well-disciplined mind and an extraordinarily precise memory full of often gossipy facts and observations. Academic by nature, he became a distinguished architectural historian and eminent authority on the colonial churches of Mexico and on the Renaissance architecture of Venice. For many years he was the director of the architecture department of the Museum of Modern Art. In the early thirties John McAndrew and Katherine Anne Porter were the core of George's circle of close friends in New York.

George's photographs were exhibited at the Julien Levy Gallery from February 1 through 19, 1932, along with Walker Evans's. The combination of Evans and Lynes must have gratified Levy's taste for combining incompatibles, which made what he regarded, perhaps, to be a surrealist statement. It is difficult to understand Levy's rationale, for the images of the two artists did not dovetail, nor did they create, in juxtaposition, contrasting differences or complementary statements. Evans's photographs are observations on the human condition; social statements in which even architectural images comment on those who built and occupied them. George's images, on the other hand, had nothing to do with poetic or melancholic photojournalism, though he may have admired its capacity to capture accidental beauty. What interested George was complete control over the lens, light, and subject. He did not use props to symbolize his subject's mood or occupation, he used them for compositional purposes. Almost from the beginning George used double exposure,

montage, and airbrushing to alter the ordinary and nudge it into the realm of fantasy. His pictures were nearly always contrived compositions meant to overcome the commonplace nature of the objects or subjects portrayed. In a letter to Monroe, in which he thanks him for designing the announcement for the upcoming show at The Leggett Gallery at the new Waldorf Towers and comments on his Levy Gallery show, George wrote: "The announcements are too beautiful. I want to write that first. The type you used for 'portrait photography' makes me dizzy with delight, and I want my tombstone engraved with it. I have received hundreds of envelopes (they must all be here) and one package of announcements. . . . I expect the rest will arrive within a few days. I can hardly believe in the quickness and the cheapness of your management. Is it possible the whole thing cost only $25; if it is more you must let me know. Barbara's $150 seems sufficient for everything, especially since I am renting frames from Julien and will not have that expense. (My H. of P. bill, being personal, will have to wait a bit.) Whatever this show may become, I fancy the announcements alone will be good advertising. I feel that way about it. Isn't the one Julien did poor by comparison? Of course, George Lynes and Walker Evans do balance. But next year I will insist upon the full name. This year I was not consulted.

"The show at Julien's has been all alarums and excursions. And I have had more annoyance than pleasure out of it. He opened the wire you sent, for example, and casually put it aside; if John had not discovered it, I might not have received it at all. There were other things of that sort. And all his plans for publicity miscarried, although I got one or two pretty if short notices. On the other hand, I seem to have a distinct preference over Evans (he is good, but monotonous), and the opening was extremely well attended. There is to be one week more of it, yet it is already ancient history. One thing happened, however, which may lead to something. Dr. Agha of Condé Nast was impressed by my 'new process' pictures, and had a set of them sent down to show the directors who liked them and who have asked to see a portfolio of my other things. If anything comes of it, I shall be surprised. Agha (a Turk or

Armenian) was on the *De Grasse* last year, and I haven't a very good impression of him. But I shall do all I can. We shall see."

Monroe arrived in New York on March 11, 1932, in time to see George's show at the Leggett Gallery. After three weeks in Englewood and New York, he traveled on April 4, to Evanston, Illinois, to see his family. On April 23 Monroe joined George in North Egremont, and in mid-May they traveled together back to Europe.

It was not an exciting summer visit for George; he was poor and quite dependent on the Harrison of Paris partners. This time he did not go to see Gertrude and Alice in Bilignin, though he wrote them to say he walked past Gertrude's empty studio on the rue de Fleurus and was sorry not to see them. He also told Stein that he had sold a portrait of her to *Town and Country*, but did not know when it would be published. He also informed her that he was busy taking portraits with his camera in Paris. With sardonic humor, he alluded to his financial situation: "Everybody in America pretends to poverty, though in some cases, mine for example, it seems real enough".

As in summers past, Barbara invited the three friends to hear music in Germany. That June it was Beethoven in Bonn and paintings along the way. Van Hoogstraten was conducting Beethoven's nine symphonies, three piano concerts, the violin concerto, the seldom performed triple concerto, and several trios. Not only did they attend the public performances, they obtained special permission to be present at rehearsals. George wrote: "Van Hoogstraten conducted admirably, but Elly Ney, upset about her own affairs, was not at her best." As it turned out, the most memorable event that summer was not the musical experience, the art, nor the lovely landscape. It was meeting the Texas-born writer, Katherine Anne Porter. To all of them, she became a lifelong friend.

Katherine Anne, or Miss Porter, as Glenway always called her, was a small and delicate woman with intense, penetrating eyes in an oval face with prominent cheekbones. She was forty-two when they met through Ford Madox Ford, who

admired her enormously. Though her first collection of short stories, *Flowering Judas*, did not appear until 1935, she was already regarded as a writer of distinguished accomplishment on the strength of a few short stories and book reviews. She eventually won the Pulitzer Prize and the National Book Award with *Ship of Fools* (1962). She saw herself as a Southern Belle, something she never let you forget, and she created and mythologized her own persona, inventing her own history by changing her name and acquiring a lineage of statesmen of the aristocratic South. Craving broad and exotic experiences to write about, all through the 1920s she ran back and forth between Mexico and New York, harvesting material. She loved Mexico, and it loved her back. In poor health in 1930, she returned to Mexico — this time to recuperate and to write. Her health improved but an active social life, which included the attractions of a husband-to-be and the poet Hart Crane, prevented her from accomplishing much. Her friendship with Crane, however, ended abruptly after a bitter argument in 1931, a year before his suicide. From revolutionary Mexico she traveled to Berlin just as Hitler was consolidating his power. In early 1932, she met and impressed Hermann Goering, an important member of the Reichstag. Porter wrote her friend Josephine Herbst that "she liked him and told him that her whole trouble as both a writer and a person was that she was too much a woman." It was Ford who suggested that she do the *French Song-Book* for Harrison of Paris press.

The Fall 1932 poster of Harrison of Paris publications announced the publication of *A Typographical Commonplace Book*, Glenway's *Calendar of Saints for Unbelievers*, and Katherine Anne Porter's *French Song-Book*. The first pieces were a printer's veritable tour de force. The *Typographical Commonplace Book* was prepared to exploit the possibilities of certain rarely used European typefaces, which were, for the most part, unsuitable for book printing, but when used in a paragraph or two, might be "very likely enchanting". Using brilliant texts and touching anecdotes from literature of different epochs, Monroe arranged each page individually, using a different typeface each time, thus making a volume that showed both extraordinary printing and memorable passages. The book was printed in three colors and then

bound by Huser, whose craftsmanship, already a vanishing art, made apparent the inferiority of machine-made casing. Of all the Harrison of Paris books he published, *A Typographical Commonplace Book* was Monroe's favorite.

Glenway's *Calendar of Saints* was the costliest publication Harrison of Paris ever produced. It was set entirely by hand by printers at the Enshedé foundry in Haarlem. The twelve-point Roman type designed by J. van Krimpen, which Monroe was using for the first time, "seemed to possess" according to Hugh Ford, "a natural dignity that was simple and yet appropriately aristocratic," as seen in such touches as the hairline curlicues connecting the letters C and T. Illustrated with beautifully rendered signs of the zodiac by Pavel Tchelitchew, one of the best-known Russian painters in Paris, this exquisite volume is a collection of saucy, irreverent portraits of "saints and fools," a witty rendering of the foibles and failures of Christian martyrs of the first century, who immortalized by canonization became "peers of heaven." Together they comprise a calendar for unbelievers (i.e., those unable or unwilling to accept the creed and its corollaries, because like all who succumb to love, the saints in the end are victimized, reduced to fools by their own love). "Perhaps love is always sexual", wrote Glenway in the foreword, "and it is usually hopeless sooner or later, ignorant from first to last; thankless, too soon." Neither the critics nor the public really understood that this handsomely elegant book was an indirect statement, full of pathos, on the author's view of his own love and devotion to the two men in his life, first Monroe then George. It was one examination of love that is not sexual.

Katherine Anne Porter's *Hacienda,* a story about love and betrayal set in Mexico, was published in 1934, and printing took place in the United States. It was the last book Harrison of Paris press published. The decision to stop publishing was made because, as the partners were considering returning to live in the United States, the superb printing facilities as well as the reasonable costs available in Europe could not be matched in America. Investment in future publications would

not be feasible if the traditional high standards combined with low cost to the purchaser were to be maintained.

Aside from their obvious and already mentioned qualities, Harrison of Paris books, when considered together, mirrored the emotional states of their makers, an observation noted by Hugh Ford. Eight out of the thirteen titles they published — *Venus and Adonis, Gentle Spirit, Carmen and Letters from Spain, Death of Madonna, The Babe's Bed, Childe Harold's Pilgrimage, Calendar of Saints for Unbelievers,* and *Hacienda* — comprise accounts of disastrous human relationships, or more exactly, demonstrations of the failure of sexual love not because it was misplaced or too precious but because it appeared obsessive, mad, abnormal, and consequently doomed to fail out of frustration. Whether consciously or not, the press partners chose works that recommended the sublimation of physical, sexual love into a spiritual, idealized love in order to keep the desired person or object. Barbara certainly struggled with this issue in so far as Monroe was concerned. Glenway, on the other hand, lost his hold on Monroe. Unable to conceive life without him, Glenway embraced the notion that true love was not sexual or some kind of fanatic devotion that might lead to martyrdom but a sincere and friendly love, a platonic devotion. He called it *caritas*. This permitted him to subscribe to the belief, also shared by George, that one could truly love someone and at the same time have a physical relationship with someone else. Monroe's romanticism and his instinctive, passionate response to beauty which, when combined with his generosity and natural inability to deliberately hurt, often placed him in situations where pure, non-sexual love for one person readily coexisted with strictly physical attraction of another. George instinctively differentiated the true, everlasting love he felt for Monroe from what he felt when he had a sexual encounter, which he viewed as an occasional physical and emotional necessity. But regardless of perspective, the fact remained that Monroe was central to all their interests, and each one of them, including Monroe himself, was forced to accommodate his or her love to suit Monroe's nature.

Whatever arrangement had been worked out for the last couple of years nearly broke down at the end of 1932, when Barbara took Monroe to China to visit Bernardine Szold Fritz in Shanghai (plates 141–146). George had sailed home earlier that year to find that his precious dachshund, Carl, had died. This compounded a sadness that he had brought back with him from Paris. There had been words to the effect that Monroe and Barbara may marry. With Carl gone, the photography business at a stand still, and no studio in which to work in in New York, George was desperate. In early October, Monroe informed George that he and Barbara were going to Shanghai and were sailing from Venice on the SS *Conte Rosso* on November 10 (plates 127–128). They were planning to stay with Bernardine for two months, and then travel to Peking and Japan. Since the books were in their last stages, they were going first to London to look after the binding, and then to Scotland to see Barbara's father. "From London we go directly to Venice. Glenway is staying home to write his new short novel. The Orient doesn't tempt him in the least, and he is feeling in a working mode, so he will stay here in Paris. We shall be back in Paris about March 5th." To this George answered: "I am not unmindful of the fact that trips to China sometimes turn out to be steps toward matrimony (Bernardine had married Chester Fritz after a trip to Shanghai). I should hate that, although I should agree. But why I should be writing to you anything except that I want you in my arms, now and forever, is scarcely understandable. And I do not understand why this separation should be harder than the others, why I should need you more. Other Winters I have been depressed, and justifiably; this Winter I am discouraged and excited. It makes no sense. And just now I want everything to make sense. Write me a long letter before you set out on your travels. That will help. I love you more than I can tell. George. My love to Barbara and to Glen. October 25, 1932."

Unable to fully comprehend and unwilling to accept what was really happening, George convinced himself that perhaps he had not done or given enough, that over the years he had not let Monroe know how much he really loved him. That

he never loved anyone else, that he had always been faithful to him, that last summer's trysts with Knollys' friend and with Moore Crosthwaithe were meaningless "flights of fancy," that he looked upon him as his future. On November 29th, George wrote Glenway: "... and Monroe must realize, or must be made to realize, that I want only him and not only forever but now. It really is as simple as that. But the important thing in all these connections is, and perhaps neither of you remember, that I was sent back to America in September with the understanding that, if it seemed possible (for I gather it seemed desirable), Monroe might marry. And that has not been pleasant to contemplate. My imagination is not good enough for me to be able to come to any conclusions about a happy ménage à quatre; moreover I have felt Monroe has his hands full enough with you and me. Once or twice I have felt strong enough, have tried to prepare myself, to make the sacrifice; alas, it does not last! But I take comfort from the fact that you do not even mention this in your letter. And lately I have tried not to think of it at all, for it frightens me. Even if it were not for that, you know how often, just so often, I have periods of despair about making my way in New York, building a career which will keep me more and more in New York (at least in America), while his life, through you, through H. of P. is bound more and more to Europe. And I do not blame you for that either, which is a wonder." As a postscript he added: "You must realize I have a horror of the sort of life I led before I knew Monroe." On the same day, George wrote Monroe a letter, addressing these same issues: "Have these other winters been dreams, or lived in a dream! But that does not matter now. My eroticism is well in hand, my body learning again the lesson of continence. Perhaps there was too much of that sort of pleasure for me last Summer, not enough of other sorts. But, whatever the reason for my rather extreme eroticism since my return, one thing is certain. There is no pleasure in the world fine enough to compare with what you give to me, no pleasure worth caring about. The important thing is that you must not be hurt, that you must not be permitted to make utterly extraneous sacrifices. In so far as I can 'live and learn my lessons in imagination' ... well, I expect I am doing so.

"I do not, for a moment, believe that there is anybody in the world to replace you or who could give me more than you have and will always be able to. It seems scarcely credible that you should think that, by making love, I might find such a person. I have never had such an idea. How could I? I have known too much about homosexual men and, whatever else I may forget, I am not likely to forget the lesson I had learned even before I met you. Have you forgotten the Summer of 1928 when, for the first time and God willing for the last, I tried to fall in love? What a miserable thing that was. Do you think I would let you, or myself, in for that sort of nonsense again? Monie dearest, the thing for you to remember is that I am in love with you, in love as romantically, as sentimentally, as passionately, as I have ever been. And all this misunderstanding has come from my fretting about our separation, about money, and about my rather volatile, perhaps incurable, certainly harmless, fancies about male flesh in general. Perhaps the one thing in the world I could bear less well than any other is to be definitely cut off from you erotically. Please try to remember that, along with everything else, it is frightfully important to me. I have always wanted all of your love for myself. How stupid I should be to ask what I was not willing and prepared to give."

Traveling with Monroe and Barbara on the *Conte Rosso* was Sir Victor Sasson and his sister-in-law Princess Ottoboni. Owner of Shanghai's principal office building and two of its leading hotels, Sir Victor was one of that municipality's richest men. He was a close friend of Bernardine and Chester. Sir Victor bought five hundred dollars worth of Harrison of Paris books to give as Christmas gifts, and the princess bought a set of titles as well. Sir Victor's was the biggest single order they ever had. After going through Ceylon, Singapore, and Hong Kong, Monroe and Barbara arrived in Shanghai where they were met by Bernadine and Chester Fritz and were taken straight to their house for dinner. To his father Monroe wrote: "I have never dreamt, before coming, that there would be so many charming people here, especially among the English speaking Chinese—a number of whom we have already

met. All the wealthy Chinese live in the International Settlement, for protection, because it is really the only place in China where they are reasonably safe from war, and even here they are often kidnapped. Kidnapping is an important industry here—and nearly every day some wealthy Chinese is kidnapped and held for ransom, but they never touch the foreigners—they aren't rich enough, in the first place and make too much fuss in the second—while the Chinese always pay up. A General Chu who is a big Chinese banker here came to lunch today, with a guard of three huge Russians in his car—none of the wealthy Chinese here ever move without a bodyguard . . . Everyone here plies his trade in the narrow streets—banker and dentist alike—and the dentist has in a bowl beside him all the teeth he has ever pulled, by way of an advertisement of how successful he is. I received sad news when I arrived here—a cable from George Lynes saying that his Father had died. I cannot imagine what happened—he was always in good health;—I was always devoted to him. His death is bound to make things difficult for George because Mrs. Lynes will have to withdraw to the Great Barrington house now."

George was not quite twenty-five when he left Englewood and moved into his studio on the parlor floor of an old grand private house located at 44 East Fiftieth Street, a fashionable address between Madison and Park Avenues. His hair, which was turning prematurely gray, exaggerated rather than contradicted his youthfulness. But he knew that if he were to prosper, he had to look beyond the portrait business and the making of pictures for exhibitions, and enter a world of fashion photography where there was money to be made. Sometime that spring he sought the help and advice of Fredericka Fox, who was familiar with the fashion world and knew how to break into it.

But in April, George received from Barbara a letter inviting him to come to Europe and offering to pay his rent in New York while he was away. Having heard from Monroe about George's financial difficulties and knowing how much he meant to Monroe, Barbara was moved to extend the invitation. At this point, Monroe and Barbara had had a change of heart about marrying. George accepted Barbara's

invitation, and a few days after his arrival in Paris, he, Monroe, Glenway, and Barbara set out on a trip to Frankfurt, Germany, to make arrangements for the printing of one of the Harrison of Paris books. Barbara had sold her Renault and bought a Ford which George drove. They seemed a happy quartet, especially now that George and Monroe were behaving as in the old days (plates 136–138, 149). It had been raining in Frankfurt, but as George wrote: "two days of sun sufficed to make me brighter and certainly as red as any boiled lobster. There is a remarkable float on the Main, just three blocks away: a sort of raft . . . big as two city blocks and all set about with pools and Ping-Pong tables and twenty-feet palms in tubs, and over-run by the youth of the city in search of tan and physical culture. . . . It also has a nice zoo . . . where I lost my heart to a silver gibbon, and Barbara threatened to import one for me from Java." On that trip Barbara gave George a Rolleiflex, the new snapshot camera. From Frankfurt they traveled up the Rhine and then to Meerots, Holland, to see the great printer and designer, J. van Krimpen.

In late July, Glenway, Monroe, and George went to Spain, while Barbara went to Scotland and shot grouse with her father. In Spain the trio visited Avila, Santiago de Compostela, Valladolid, and Salamanca, a beautiful and ancient university town (plates 139, 147, 148).

The Autobiography of Alice B. Toklas was published in August, 1933, and on September 5, George wrote Monroe: "But did you see what funny Gertrude perpetrated in our honour. 'There was one or two under twenty, for example George Lynes, but they did not count as Gertrude Stein carefully explained to them.' And 'there was also Glenway Wescott but Glenway Wescott at no time interested Gertrude Stein. He had a certain syrup but it does not pour.' You gave me that certain syrup, the first time I met you, etc. . . . " And about their summer together George wrote: "It seems to me that all the poetry I can remember has to do with you and me, and in particular with you there and me here. Christmas seems terribly far away. Oh, I know that time passes, but that does not help when I have a lump in my throat, when tears are near the surface, just because I want you."

Even before George's letter reached him, Monroe was writing his brother Richard about the discovery of a small spot of tuberculosis on Barbara's left lung. "It has just begun," Monroe wrote. "So they say they can cure it in four months if she will go to Davos [Switzerland] immediately. She is here now, very depressed by the prospect, gathering up her belongings." Monroe spent a great deal of time with Barbara in Davos (plate 156), but on November 28, 1933, he arrived in New York to stay with George in his apartment on Fiftieth Street. The news from Paris was that Glenway and Jacques Guérin were parting ways.

In the early months of 1934, Barbara was still in Davos and Monroe her constant companion. Monroe told her he had seen Katherine Anne Porter in Paris and that her husband was gloomily drinking by himself and that she was in very poor health and unable to write. An examination had revealed that Porter had severe bronchitis but not tuberculosis. Monroe and Barbara wrote Porter, urging her to join them in Davos for several weeks of rest, and sent her the fare of one hundred dollars, an advance on *Hacienda*, her piece for Harrison of Paris (plates 152–155). Barbara persuaded Katherine to stay in Switzerland until the revised version of *Hacienda* was ready and to accompany her to the Salzburg Festival at the end of May.

In America, George's professional life began to take off in another direction. After consulting with Frederika Fox, he found Catherine Cleary. She showed him what to look for and what to highlight, and told him what art directors wanted. George also hired Mary Conover Brown, known as "Mims," who later married Paul Mellon, the benefactor of the National Gallery in Washington. Brown was the person who persuaded George to give up his Fiftieth Street studio and move into the less expensive basement of an ample brownstone at 214 East Fifty-eighth Street.

In mid-June of 1934 Monroe and Glenway returned to New York from Europe entertaining the option to remain in the United States permanently. After a brief stay in George's basement apartment, they were joined by Lloyd Wescott. By late summer Glenway and Monroe decided to stay in New York and moved into an apartment house on Madison Avenue in the thirties, opposite the Morgan Library.

Although George continued to live in his basement apartment on Fifty-eighth Street, they decided that if they could find an apartment they thought suitable and could afford, they would set up a ménage à trois. After much searching they found an apartment at 48 East Eighty-ninth Street on the corner of Madison Avenue; it was big enough for them and a live-in maid.

Later that year, in late 1934, enticed by Monroe and Glenway, Barbara came to visit them in New York, where she met Lloyd, they fell in love, and were married on April 8, 1935. Whether intended or not, by marrying Lloyd, Glenway's brother, Barbara kept Monroe by her side for as long as she lived.

After they moved in together and established their ménage at East Eighty-ninth Street, the relationship between Monroe, George, and Glenway had to be reconfigured. Even in optimal triumvirates, there is never an even and equal sharing of physical and emotional elements. When the fog had lifted, Glenway found himself in third place, a position that involved an intense mental attachment to both Monroe and George, with an occasional sexual contact with George when Monroe was away. Monroe and Glenway had discontinued their physical attachment when Glenway's relationship with Guérin became serious. This configuration remained stable for a number of years; in fact, until 1937, when George began to reject Glenway's advances, and suggested that he "discover for himself some new substitute lover."

Of course, though he didn't admit to it at first, this struck him as a bolt of lightning, forcing him to liken himself to a trained falcon whose master did not care whether he lived or died: "So the falconer plucks off the falcon's dark hood, and sharply explains, and urgently points across the plain where, somewhere there may or may not be wily partridge, banal rabbit. But the falcon, blinded by its dream in the darkness, cannot yet see much; and infatuated with the master's hand upon which it sits, by which in the past it has been fed steadily, it cannot care much; and with the tight pain in its gut from long fasting and yearning, it cannot fly very well."

Glenway was a triangular man, and as the Marshallin in Der Rosenkavalier, he had to depart alone. Again, readjustment, accommodation. . . for the sake of love, ideal love, possibly the true love of one's life.

Anatole Pohorilenko

The Albums

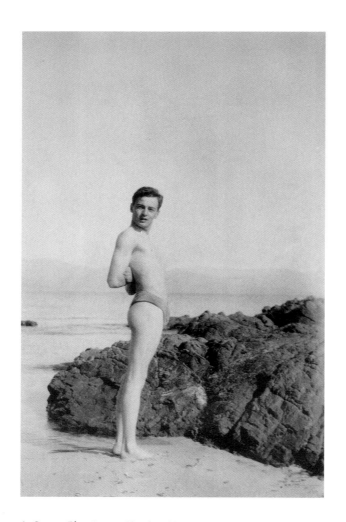

1. George Platt Lynes, Ajaccio, 1928

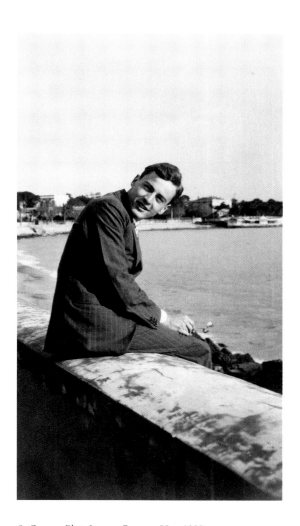

2. George Platt Lynes, Cannes, May 1928

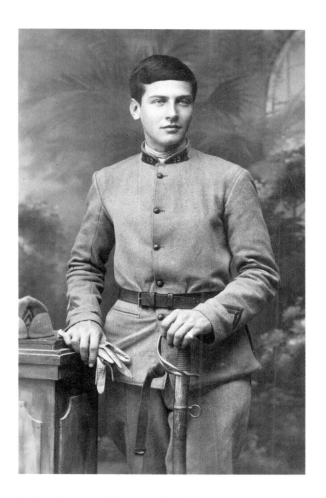

3. Jean Bourgoint, Nîmes, October 1926

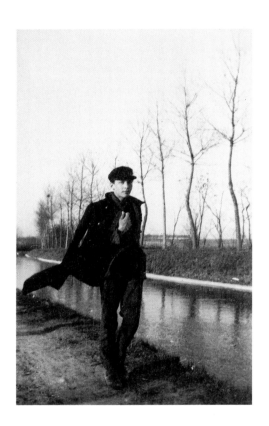

4. Jean Bourgoint, Paris, June 1926

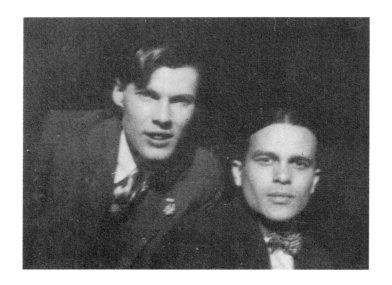

5. Glenway Wescott and Monroe Wheeler, 218 Boulevard Raspail, April 1925

6. Glenway Wescott, 1925

7. Monroe Wheeler, 1925

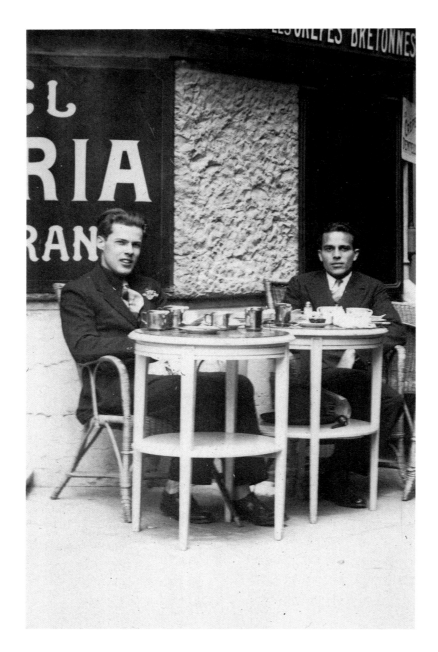

8. Glenway Wescott and Monroe Wheeler, Aix-les-Bains, May/July 1926

9. Berardine Szold and Glenway Wescott, May 1926

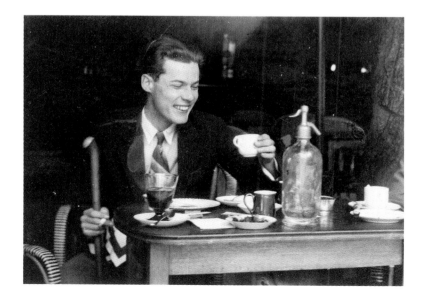

10. Glenway Wescott and Jean Bourgoint, Paris, 1926

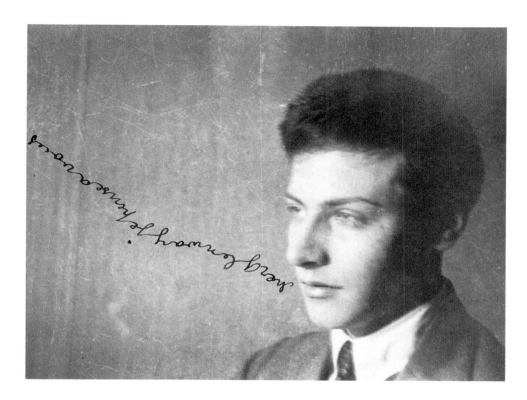

11. Jean Bourgoint, 1926

12. Jean Cocteau, 1926

13. Jean Cocteau, La Barque Orphée, 1926

14. Jean Cocteau, 1926

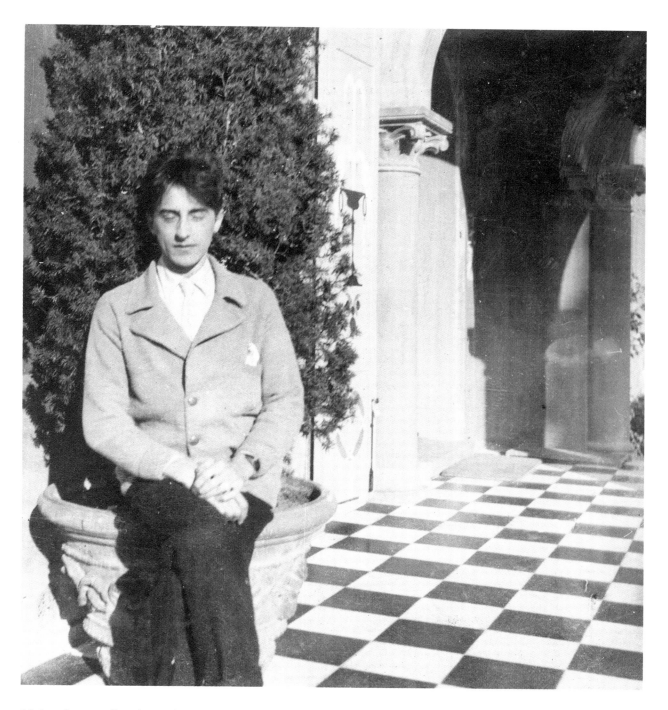

15. Jean Cocteau, à l'age de . . ., 1926

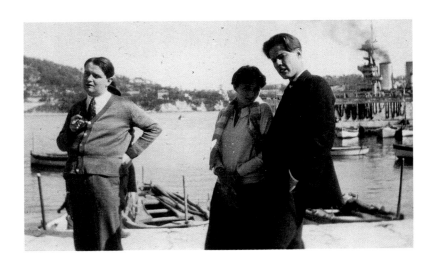

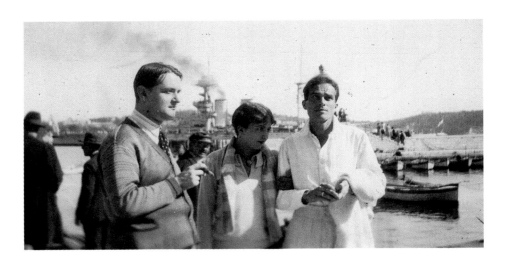

16. George Auric, Glenway Wescott, Monroe Wheeler and Friend, Winter 1925–26

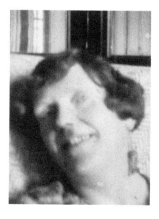

17. Peter Morris and Mary Butts, Hôtel de la Plage, Pouric, July 1925

18. Peter Morris, Egypt, Winter 1925–26

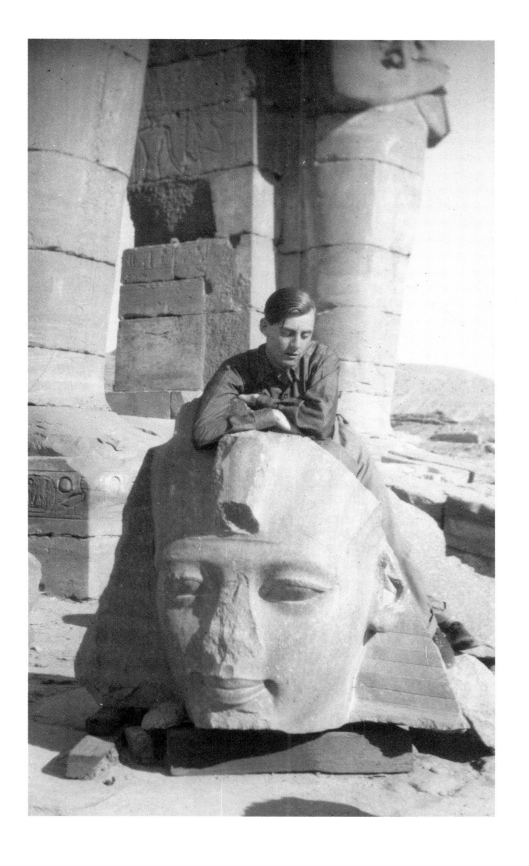

19. Monroe Wheeler at "La Cabane," 1926

20. Patio behind "La Cabane," 1926

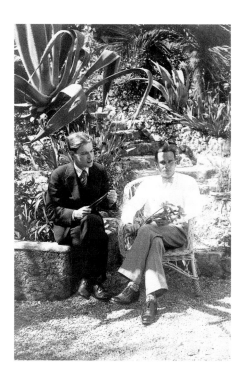

21. Glenway Wescott and Monroe Wheeler, "La Cabane," 1926

22. Beach scene, Cannes, 1927

23. Composite of Paul Soutter, 1927

24. Paul Soutter and Juan and August, 1927

25. Paul Soutter and Juan, 1927

26. Paul Soutter and Friends, 1927

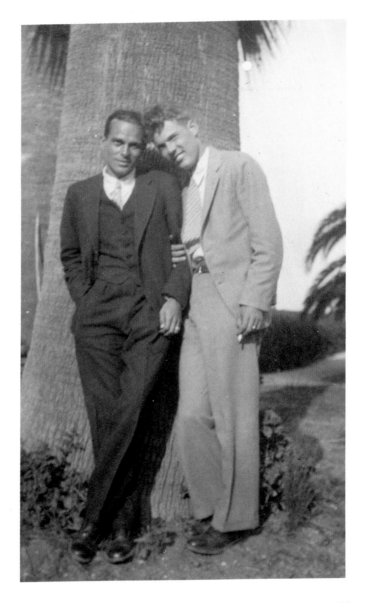

27. Monroe Wheeler and Glenway Wescott in a Park on the Riviera, 1927

28. Monroe Wheeler and Glenway Wescott, Nice, 1927

29. Kate Drain Lawson, 1927

30. Ingeborg Gloria Lee, Dorothée Nolan, and Arthur Lee, 1927

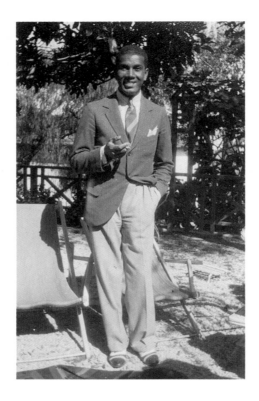

31. Paul Robeson at "La Cabane," 1927

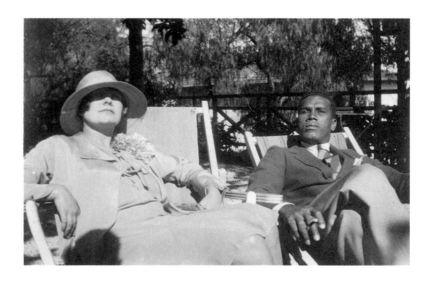

32. Paul Robeson and Guest at "La Cabane," 1927

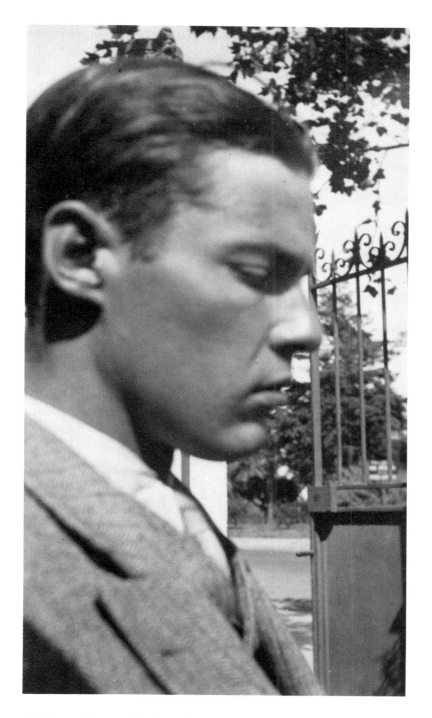

33. Glenway Wescott at "La Cabane," 1927

34. Glenway Wescott and Jean Bourgoint, 1927

35. Composite of Monroe Wheeler, 1927

36. George Platt Lynes, Englewood, New Jersey, 1927

37. George Platt Lynes, 1927

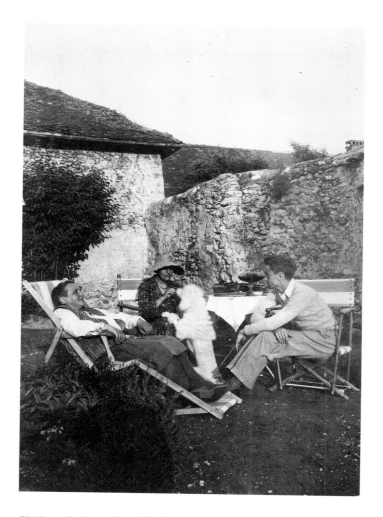

38. Gertrude Stein, Alice B. Toklas, and George Platt Lynes, Belley, 1929

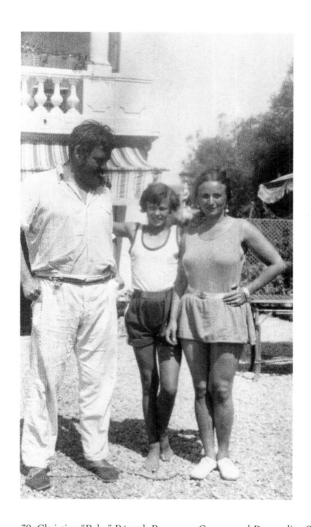

39. Christian "Bebe" Bérard, Rosemary Carver, and Bernardine Szold, 1927

40. Arthur Lee's *Rhythm* and Tony Sansone, 1928

41. Arthur Lee's *Rhythm* and Tony Sansone, 1928

42. Yvor Winters, Palo Alto, California, 1927

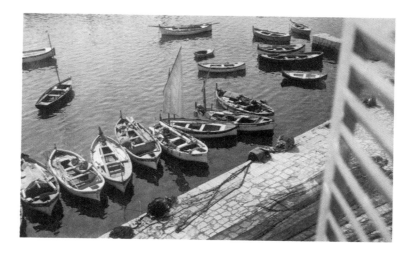

43. View from the Hôtel Welcome, Villefranche-sur-Mer, 1928

44. Glenway Wescott at "La Cabane," 1928

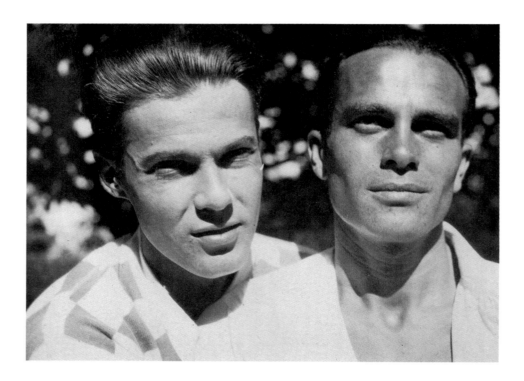

45. Glenway Wescott and Monroe Wheeler, 1928

46. George Platt Lynes, Villefranche-sur-Mer, 1928

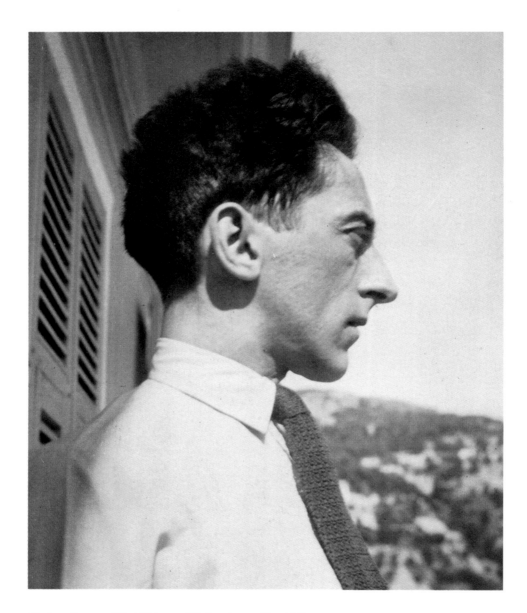

47. Jean Cocteau, Hôtel Welcome, Villefranche-sur-Mer, 1928

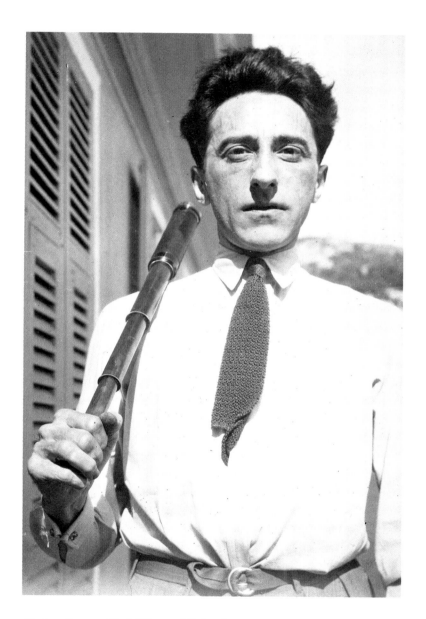

48. Jean Cocteau, Hôtel Welcome, Villefranche-sur-Mer, 1928

49. Monroe Wheeler, Ajaccio, 1928

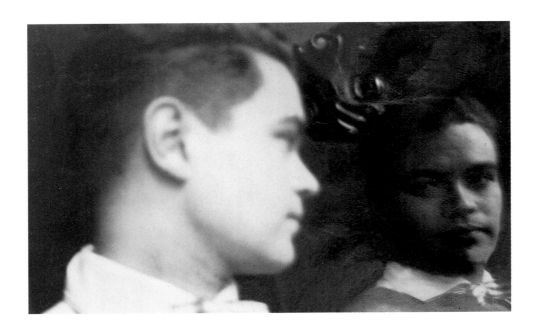

50. René Crevel and His Mirror Image, Paris, November 1928

51. George Platt Lynes's Reflection in a Tray, "La Cabane," August 1928

52. Wesson Bull and Mary Butts, Villefranche-sur-Mer, May 1928

53. Mary Butts, Villefranche-sur-Mer, May 1928

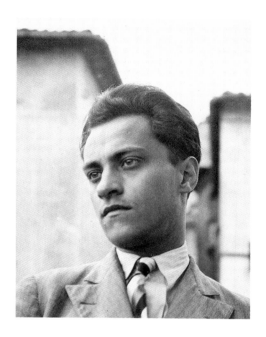

54. Raymond Radiguet, Villefranche-sur-Mer, c. 1925

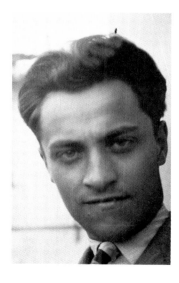

55. Raymond Radiguet, Villefranche -
sur-Mer, c. 1925

56. Clemence Randolph, George Platt Lynes, and Hugh Brook, Antibes, May 1928

57. Hugh Brook, Villefranche-sur-Mer, June 1928

58. Hugh Brook, Antibes, June 1928

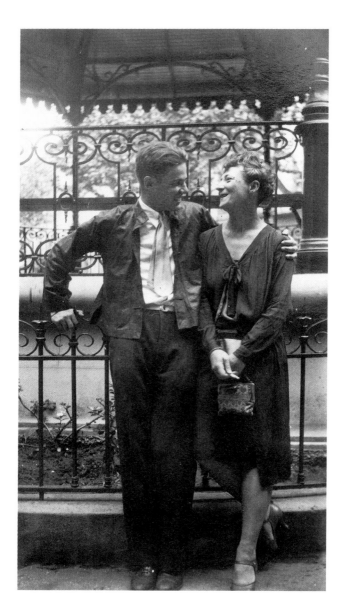

59. Glenway Wescott and Mary Reynolds, 1928

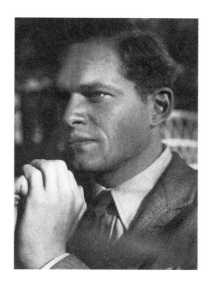

60. Eardly Knowlys at "La Cabane," 1928

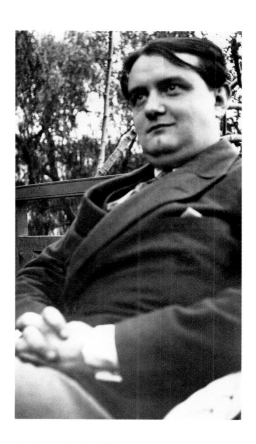

61. George Auric, 1928

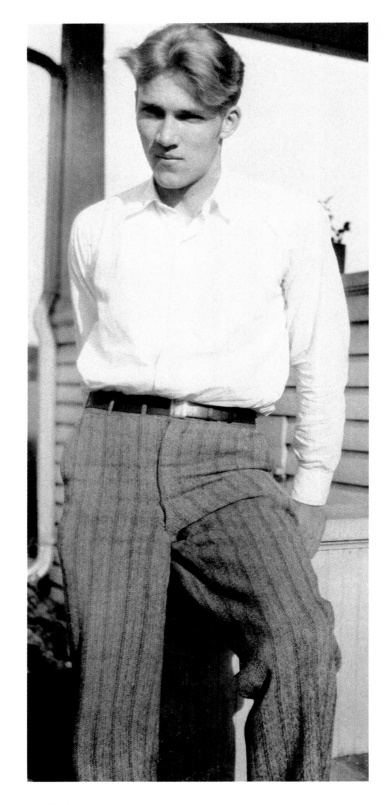

62. Lloyd Wescott, 1928

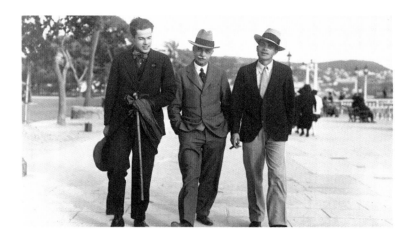

63. Glenway Wescott, R. L. Cottonet, and Monroe Wheeler on the Promenade des Anglaise, Nice, October 1926

64. Kate Lawson and Glenway Wescott at "La Cabane," 1928

65. Monroe Wheeler in His Ford, "Fear and Trembling," 1928

66. George Platt Lynes at "La Cabane," 1928

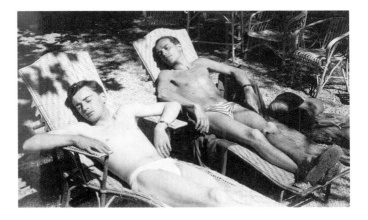

67. George Platt Lynes and Monroe Wheeler at "La Cabane," 1928

68. George Platt Lynes, Englewood, New Jersey, 1928

69. George Platt Lynes and Monroe Wheeler, 1928

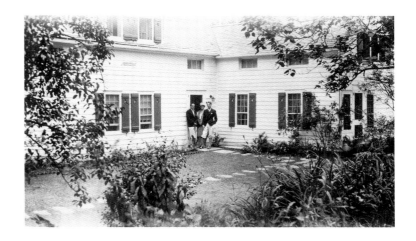

70. Monroe Wheeler, Adelaide Lynes (George Platt Lynes's mother), and Russell
Lynes (George Platt Lynes's brother), North Egremont, Massachusetts, 1928

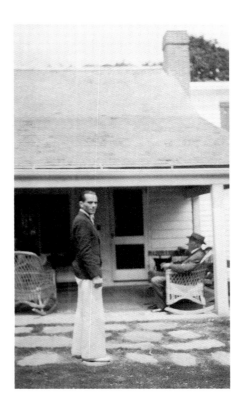

71. Monroe Wheeler, North Egremont,
Massachusetts, 1928

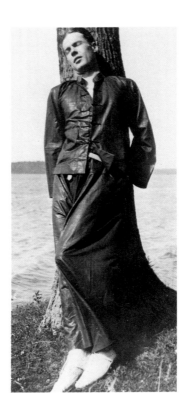

72. Glenway Wescott in Chinese
Waxed Silk, Ripon, Wisconsin, July
1929

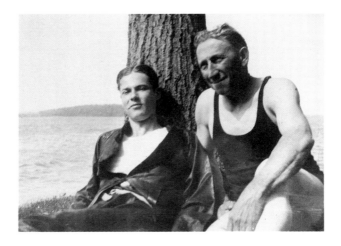

73. Glenway Wescott and Bruce Wescott (Glenway Wescott's
father), Ripon, Wisconsin, July 1929

74. Lloyd Wescott at a Lake, Wisconsin, July 1929

75. Monroe Wheeler, 1929

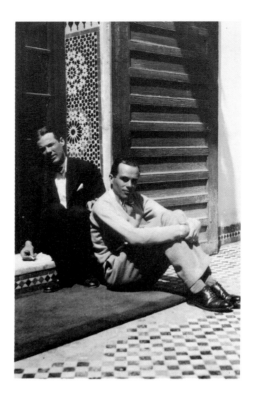

76. Glenway Wescott and Monroe Wheeler,
Morocco, 1929

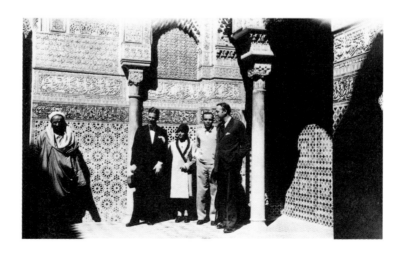

77. Monroe Wheeler, Glenway Wescott, and Friends, Fez, Morocco, 1929

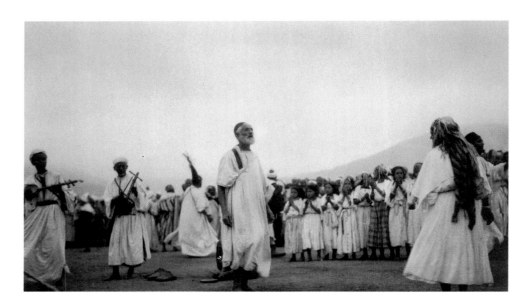

78. Public Arabic Dance, Morocco, 1929

79. Monroe Wheeler, Souk el Arba, Morocco, 1929

80. A Bedouin Horse Race, Amiz-Miz, Morocco, 1929

81. Monroe Wheeler and Friends, Morocco, 1929

82. Glenway Wescott, Monroe Wheeler and Friends, Morocco, 1929

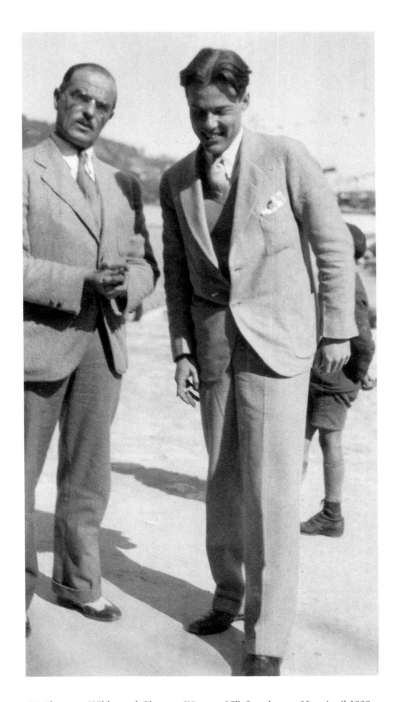

83. Thornton Wilder and Glenway Wescott, Villefranche-sur-Mer, April 1929

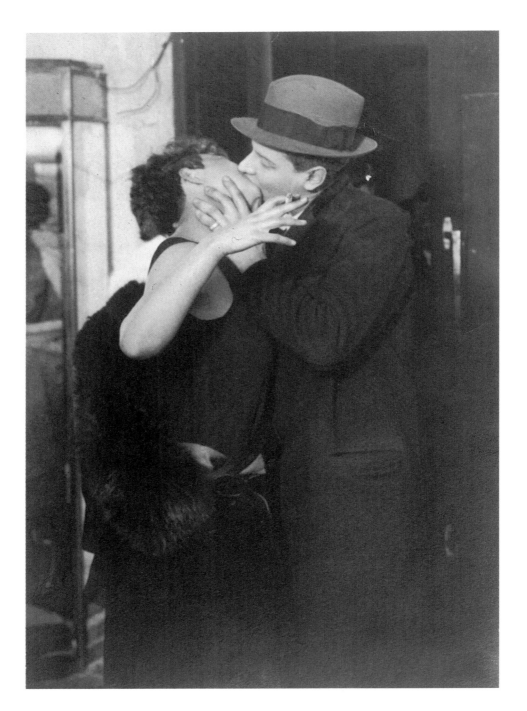

84. Lovers, Paris, 1928

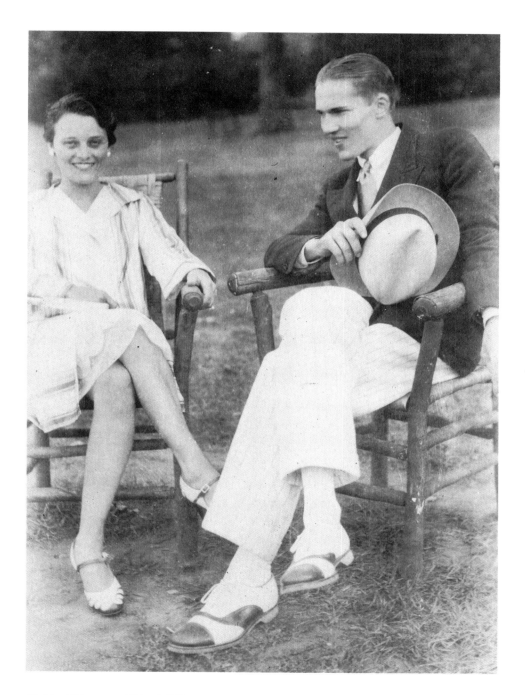

85. Lloyd Wescott and Friend, 1928

86. Still Life with Chairs, Paris, 1929

87. Still Life with Soda Bottle, Paris, 1929

88. Gertrude Stein, Paris, March 1929

89. Gertrude Stein, Paris, March 1929

90. The Headlamp of Barbara Harrison's Renault, Bayreuth, September 1931

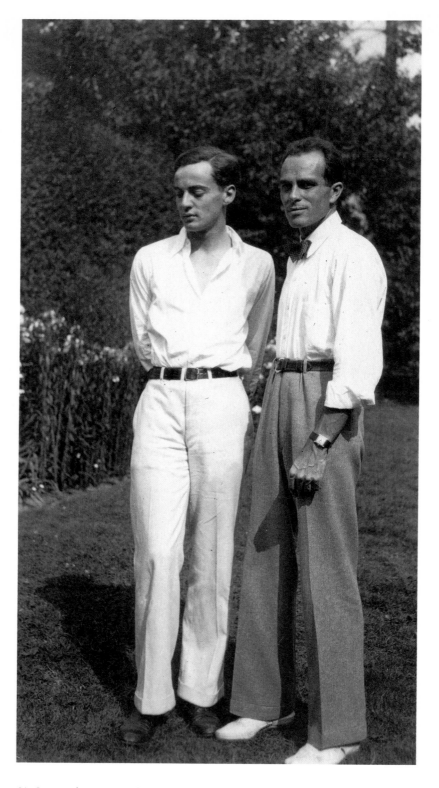

91. George Platt Lynes and Monroe Wheeler, Englewood, New Jersey, August 1929

92. George Platt Lynes and Monroe Wheeler, Bonn, June 1932

93. From the deck of the *S. S. De Grasse*, April 1929

94. Glenway Wescott, Pavel Tchelitchew, and Cecil Hope-Gill, Rambouillet, July 1932

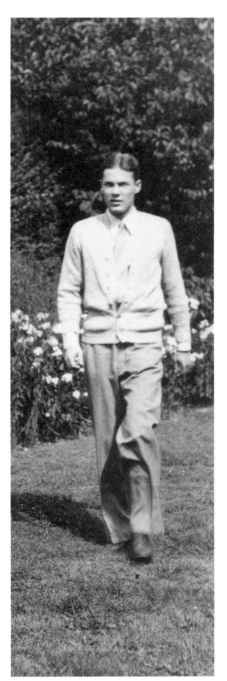

95. Composite of Glenway Wescott, 1929

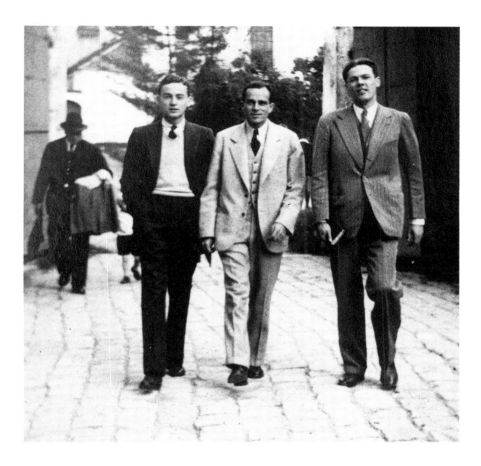

96. George Platt Lynes, Monroe Wheeler, and Glenway Wescott, Wilhering, August 1929

97. Tonio Selwart, North Egremont, Massachusetts, January 1932

98. John McAndrew, North Egremont, Massachusetts, January 1932

99. Glenway Wescott, Rambouillet, August 1932

100. Nelson Brinkerhoff, North Egremont, Massachusetts,
June 1929

101. Moore Crosthwaite, Rambouillet, August 1932

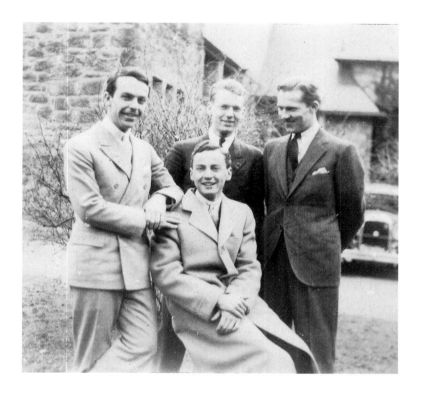

102. John McAndrew, George Platt Lynes, Russell Lynes, and Lloyd Wescott, Englewood, New Jersey, January 1932

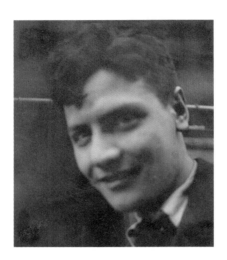

103. Jean Bourgoint, Paris, March 1929

104. Lloyd Wescott, North Egremont,
Massachusetts, June 1929

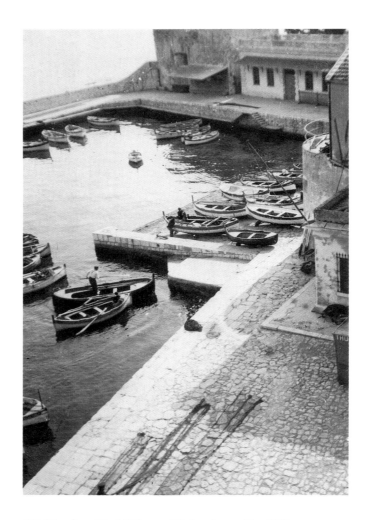

105. View from Hôtel Welcome, Villefranche-sur-Mer, 1929

106. Monroe Wheeler at the Beach, Le Touquet, 1931

107. Fishing Nets on Quai, View from the Hôtel Welcome, Villefranche-sur-Mer, 1931

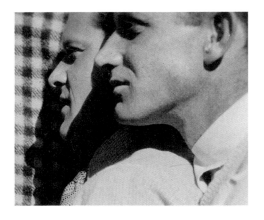

108. Eardly Knollys and Jamie Campbell, 1931

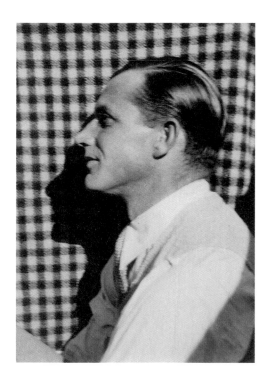

109. Jamie Campbell, 1931

110. Still Life with Chairs, Paris, 1931

111. Glenway Wescott with Friends, Villa Christina, Florence,
December 1931

112. Glenway Wescott, Villa Christina, Florence,
December 1931

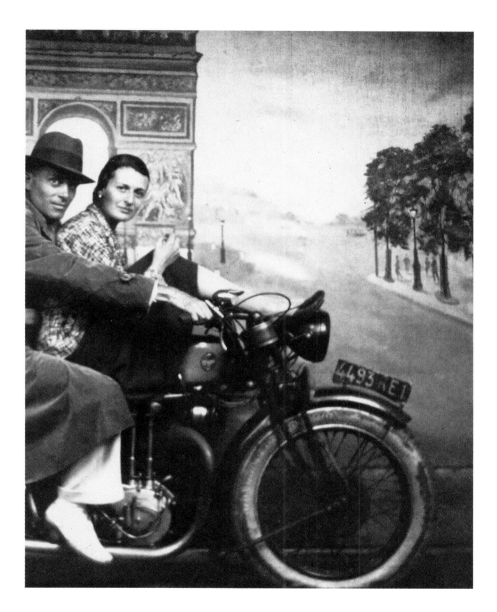

113. Monroe Wheeler and Barbara Harrison, Paris 1931

114. Glenway Wescott, Thornton Wilder, and Monroe Wheeler, 1931

115. Thornton Wilder and Monroe Wheeler, 1931

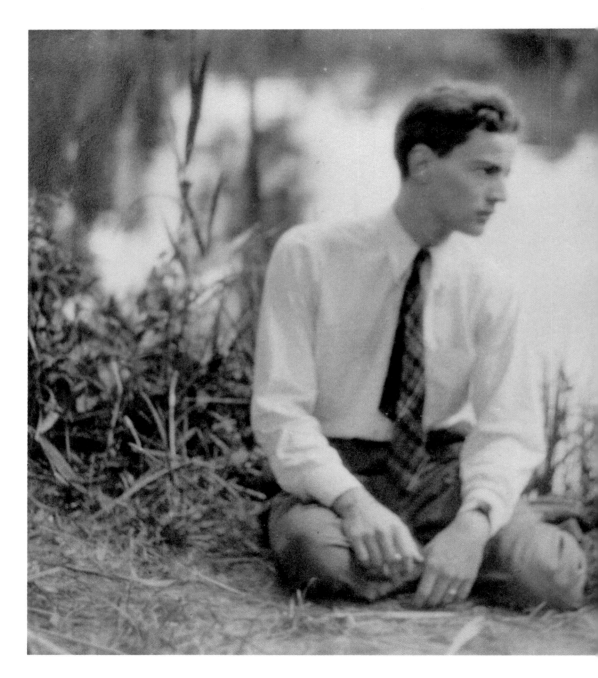

116. George Platt Lynes, Nemours, 1930

117. Monroe Wheeler, Le Touquet, 1931

118. Glenway Wescott, Hôtel Welcome, Villefranche-sur-Mer, April 1931

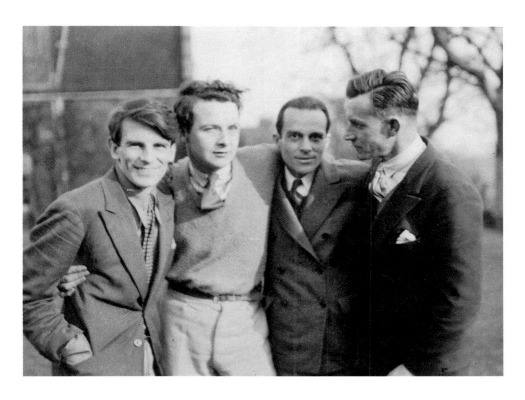

119. Monroe Wheeler and Friends, London, February 1930

120. R. L. Cottonet, Rambouillet, 1931

121. Fred Monroe Wheeler (Monroe Wheeler's father), Evanston, Illinois, November 1930

122. Ana Kienzle Wheeler (Monroe Wheeler's mother) and Richard Wheeler (Monroe Wheeler's brother), Evanston, Illinois, November 1930

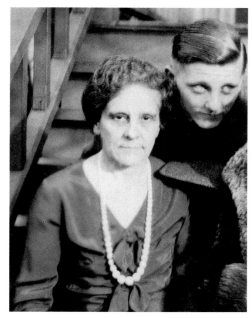

123. Elizabeth Madox Roberts and Her Mother, Springfield, Kentucky, December 1930

124. Monroe Wheeler in the Grass, Rambouillet, June 1931

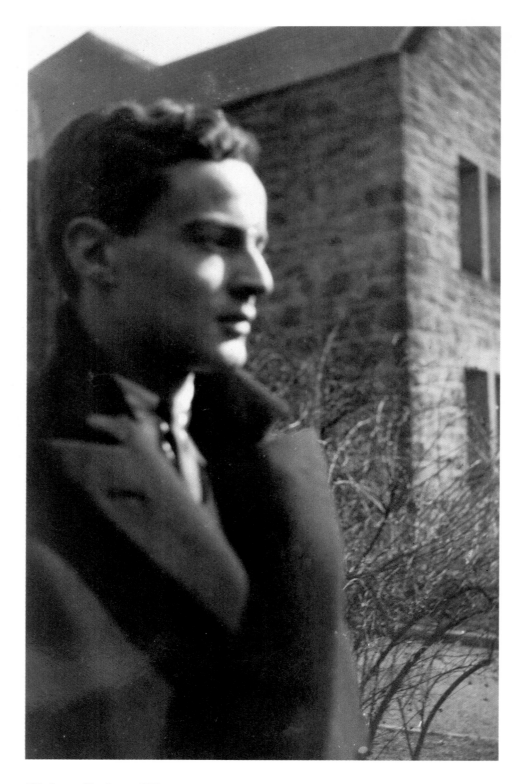

125. George Platt Lynes, 1932

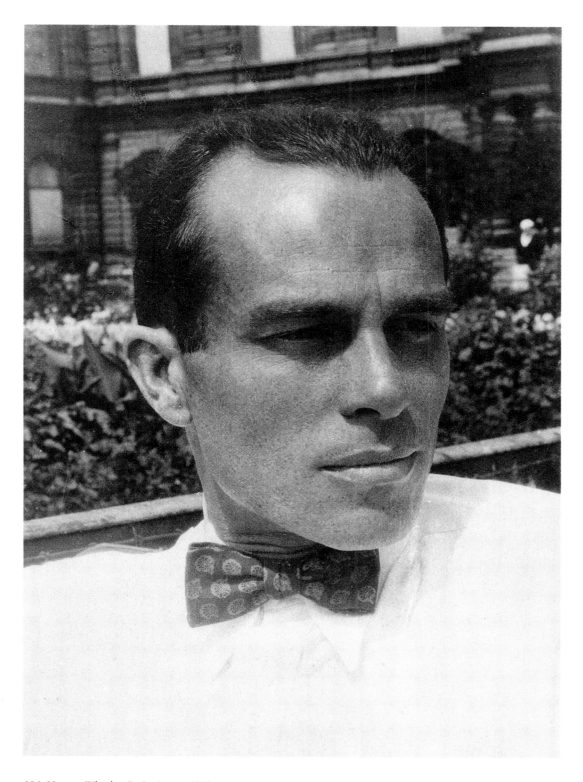

126. Monroe Wheeler, Paris, August 1932

127. Barbara Harrison and Monroe Wheeler on
the *SS Conte Rosso*, November 1932

128. Masquerade on the *SS Conte Rosso*, November 1932

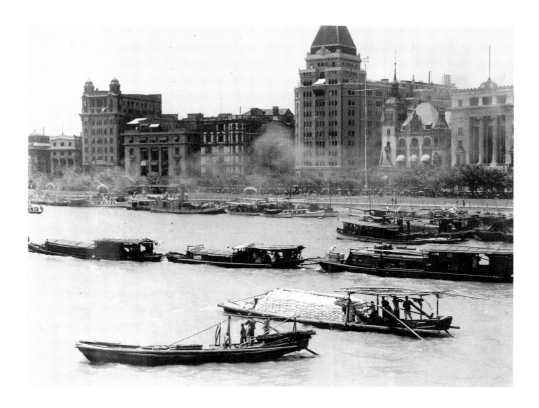

129. Arrival in Shanghai, December 4, 1932

130. The Paper Hunt, Shanghai, December 1932

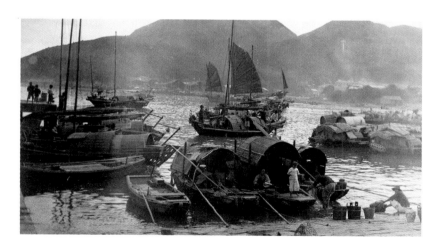

131. View of Hong Kong, 1932

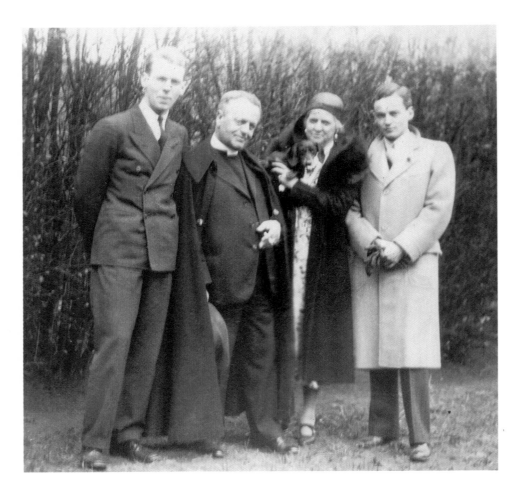

132. Russell Lynes (George Platt Lynes's brother), Joseph Lynes (George Platt Lynes's father), Adelaide Lynes (George Platt Lynes's mother), and George Platt Lynes, 1932

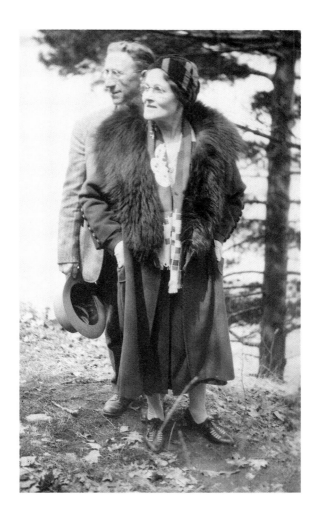

133. Glenway Wescott's parents, Green Lake, Wisconsin, April 1932

134. Monroe Wheeler and Glenway Wescott, Caux, 1931

135. Barbara Harrison and Monroe Wheeler, Caux, 1931

136. George Platt Lynes on the Mainz to
Rotterdam Boat on the Rhine, June 1933

137. George Platt Lynes on the Mainz to Rotterdam Boat
on the Rhine, June 1933

138. George Platt Lynes on the Mainz to
Rotterdam Boat on the Rhine, June 1933

139. George Platt Lynes on a Spanish Road, 1933

140. George Platt Lynes in the Garden, Rambouillet, 1933

141. Barbara Harrison, Soochow, January 1933

142. The Forbidden City, January 1933

143. The Great Wall of China, January 1933

144. Face in the Crowd, Shanghai, 1933

145. Chester Fritz, Bernardine Szold Fritz, Barbara Harrison,
and Monroe Wheeler, Shanghai, 1932

146. Bernardine Szold Fritz, Sir Victor Sasson, and
Friends, Shanghai, 1932

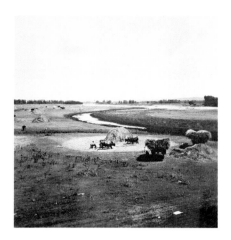

147. Spanish Landscape, 1933

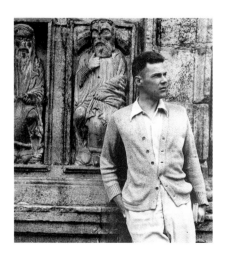

148. Glenway Wescott at Santiago de
Compostela, 1933

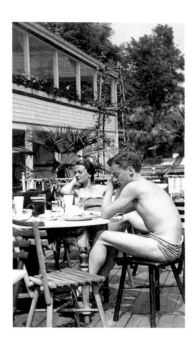

149. Barbara Harrison and George
Platt Lynes, Frankfurt, 1933

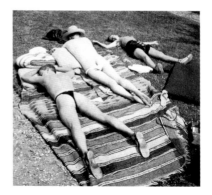

150. George Platt Lynes, Glenway
Wescott, and Barbara Harrison,
Rambouillet, July 1933

151. Barbara Harrison, 1934

152. Katherine Anne Porter, Davos, Switzerland, 1934

153. Barbara Harrison and Katherine Anne Porter, Davos,
Switzerland, 1934

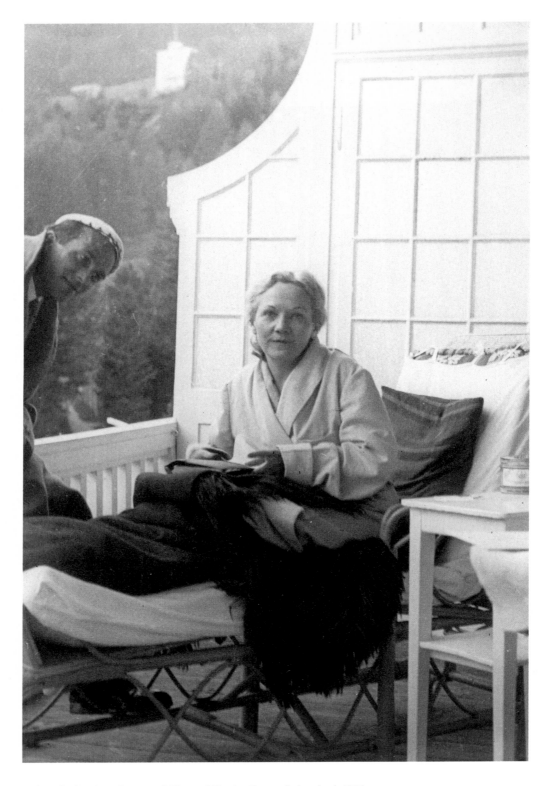

154. Katherine Anne Porter and Monroe Wheeler, Davos, Switzerland, 1934

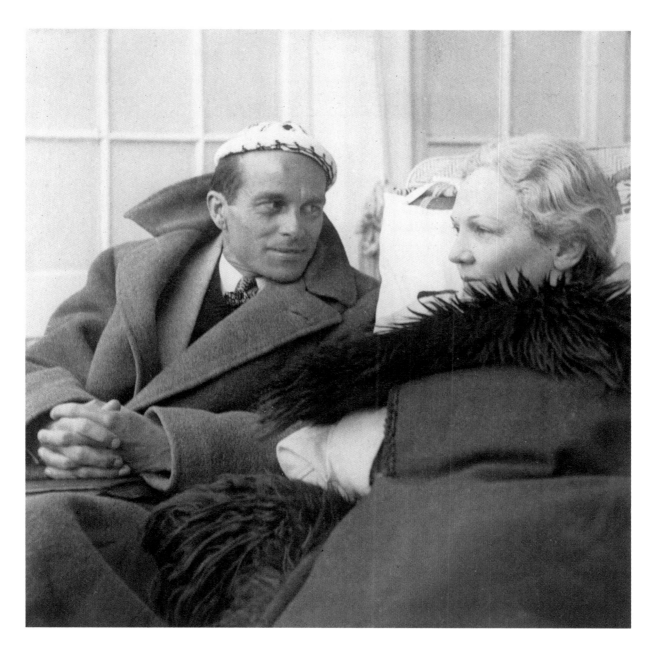

155. Monroe Wheeler and Katherine Anne Porter, Davos, Switzerland, 1934

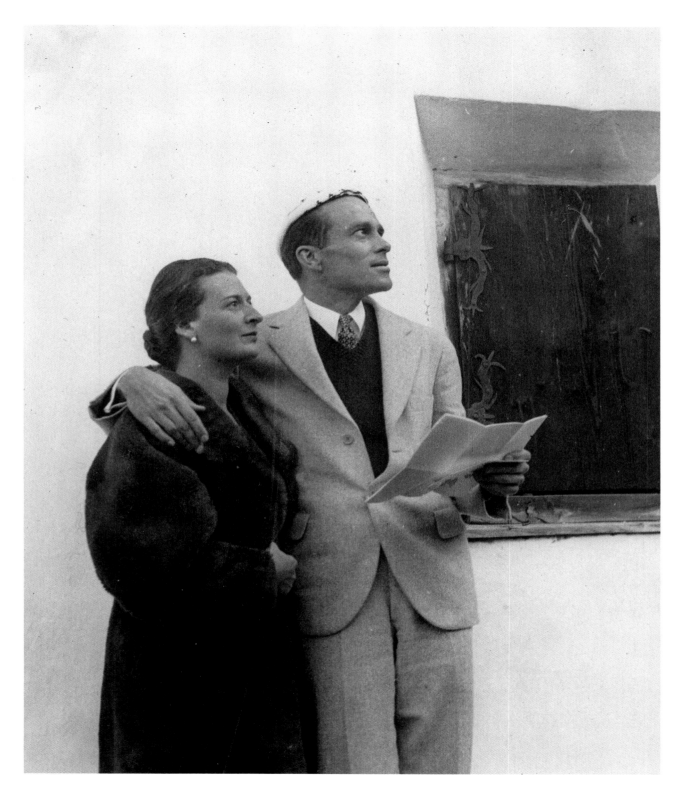

156. Barbara Harrison and Monroe Wheeler, 1934

157. Russell Lynes, North Egremont, Massachusetts, April 1934

158. George Platt Lynes, North Egremont, Massachusetts, April 1934

159. Moore Crosthwaite, Paris, May 1934

160. Maurice Sachs, St. Prest, May 1934

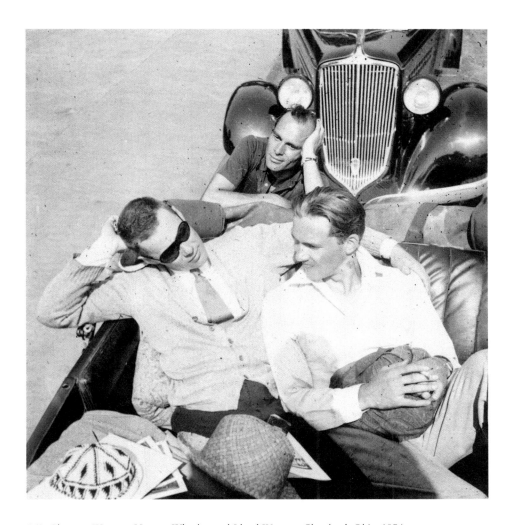

161. Glenway Wescott, Monroe Wheeler, and Lloyd Wescott, Cleveland, Ohio, 1934

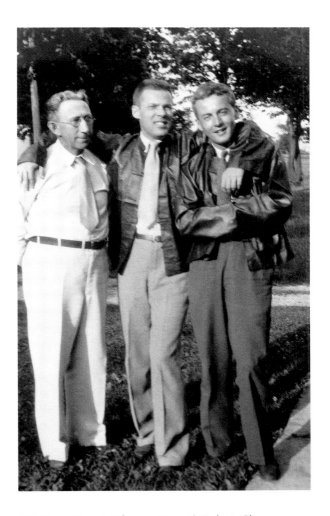

162. Bruce Wescott (Glenway Wescott's Father), Glenway
Wescott, and George Platt Lynes, Ripon, Wisconsin, 1933

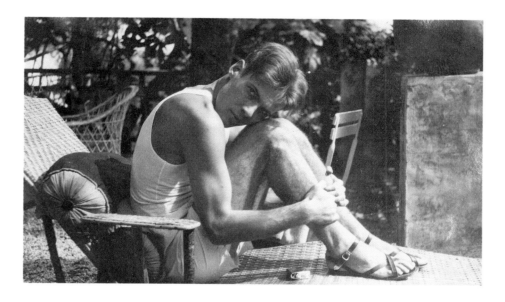

163. Glenway Wescott at "La Cabane," 1928

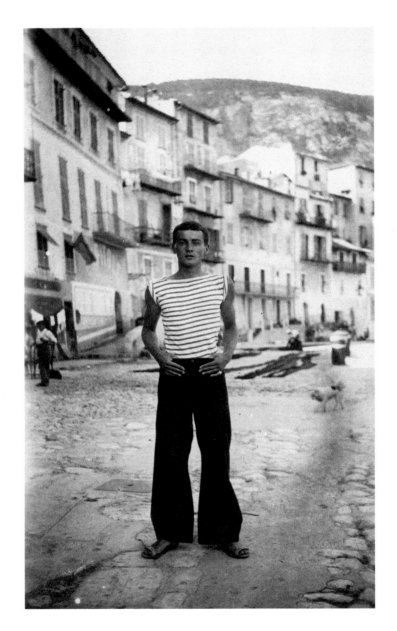

164. George Platt Lynes, Villefranche-sur-Mer, 1928

165. Monroe Wheeler, 1933

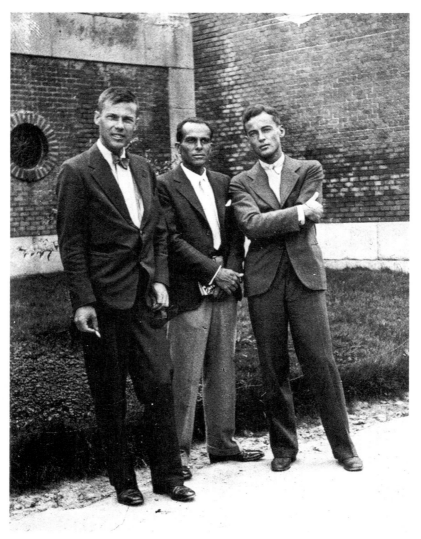

Glenway Wescott, Monroe Wheeler, and George Platt Lynes, c. 1930.

The American Years, 1935–1943

The travel albums of Lynes, Wheeler, and Wescott end in 1935, a major turning point in time for all three men. Although travel was for each a lifelong avocation, the previous ten years were unique and particularly intimate. There had been much to learn while touring together in the late twenties and early thirties—many adventures, new acquaintances, and lively experiences that often challenged the threesome's bond. It was, after all, the interwar period, marked by bohemian excess and ardent intellectual and artistic experimentation. All three men had been inspired by their interactions abroad and by the movements in music, literature, and art that had drawn so many people to Europe, notably France, which was a great bargain. With the gold standard still in place, and the U.S. dollar towering above European currencies, expatriate Americans lived comfortably for very little. Generally speaking, the travel albums underscore an exuberant, expansive time for George, Monroe, and Glenway, each of whom would reflect on this period for many years.

By 1935 several events, which were to set the course for each man's future profession, had transpired. Monroe had in 1930 successfully launched the small press Harrison of Paris, seeing it through its early successes, and, more recently, its financial challenges. In 1935 he began a longstanding association with the six-year-old Museum of Modern Art (MOMA). Glenway, having become in 1927 a best-selling author with *The Grandmothers*, had moved beyond his precocious success and was now struggling with writer's block—a situation that, infused with personal anxiety, persisted for many years before his next acclaimed novel would appear. George Platt Lynes, having successfully opened a studio out of a former speakeasy at 214 East

Fifty-eighth Street, was establishing himself as one of the preeminent photographers of the period. The younger Lynes had already participated in a number of influential photography exhibitions in New York.

The late thirties were for Monroe, Glenway, and George a time of transition, of inward growth and reconciliation, and of upward mobility. Each supported a comfortable life-style, George being the exception given his lavish wardrobe, deluxe studio accommodations, and wanton spending on entertaining friends and family. On the surface it appeared that life could not have been better for all three men during this period, notwithstanding Glenway's writing lapses and difficulty adjusting to a more permanent living situation in the United States. Struggling to write in the States, however, only compounded Glenway's need to feel connected to Europe, if only through appearance. As Klaus Mann wrote in his 1941 autobiography, *The Turning Point*: "As for Wescott, he now appears almost conspicuously European in America as he used to be conspicuously American in Europe." According to Glenway himself, he "had spoken French for too long. And I'd enjoyed all that success with my Wisconsin material and with Paris and the luxury of Paris."[1] Lasting several years, Glenway's difficulty writing and adjusting to life back in the United States intimated new complexities the threesome faced in New York.

Although Glenway recounted that he had "stayed abroad too long," his affectation signaled the beginning of a period of emotional ambivalence about his current state of affairs with Monroe and George. As Anatole Pohorilenko has pointed out, the romance frequently rocked the threesome, especially after Glenway and Monroe moved back to New York in 1934. As a young, eager-to-learn protégé, George had earlier offered both men opportunities to direct his future, to act as mentor and advisor. Romantically speaking, however, George had always been Monroe's love interest, his *object-fixe*, and this had been an emotional burden for Wescott since the three had met in 1927. Quite simply, Wescott increasingly found himself to be the odd man out. By 1935 he was struggling to produce, and to a certain extent, his combined sense of regret, loneliness, and self-pity were impeding

these efforts. The situation lasted several years, with Glenway recording in 1937: "Perhaps my never putting restraints on love, and of entering into any state of rapture which I found available, had gone. Might I now have to admit that my three-cornered relationship with [Monroe and George] was untenable, destructive, or at least unconstructive."[2]

Glenway was drowning emotionally during this period of time and writing very little; his quiet, inward struggle, revealed in his journal, was not made known until after his death. A devoted supporter of Monroe and George, Glenway was often counted on for advice, a letter of recommendation, or a polished review or profile like those he provided Lynes from time to time. According to Glenway's journal entries from the late 1930s, Monroe urged him to "write about himself," as a means to break the writer's paralysis, to ward off Wescott's insecurities and perhaps the loneliness he had grown accustomed to while observing Wheeler and Lynes together.[3] With his sexuality a recurrent theme of his journal entries of the late 1930s, it is apparent that Glenway took up Monroe's suggestion. Around 1938 he wrote a fifty-page erotic story entitled "A Visit to Priapus." Deep in metaphor, it suggested Glenway's particular sexual hunger of this period. At the same time, Glenway began using the metaphor of the falcon and the falconer to describe his unrequited desire for George, the unfulfilled love triangle of which he found himself a part. "George as falconer urged me as falcon to get after some ordinary prey," Wescott wrote in July 1937.[4] As the falconer, Glenway drew George as the master, the center of power that the falcon must obey. George had come between Monroe and Glenway, but only now had the consequences of this division become manifest, deeply affecting his writing.

The bird of prey also became a frequent reference in Glenway's correspondence of this time, especially in his letters to George and Monroe. Doubtless, it was the same metaphor that inspired his most critically acclaimed novel, *The Pilgrim Hawk*. Glenway later recounted to scholar Jerry Rosco that the hawk of the novel was "a symbol of the aging process and sexual frustration, and as an image, a

metaphor, for everything bestial and instinct-ridden."[5] Rosco has written persuasively about *Pilgrim Hawk*'s main characters as stand-ins for Glenway, Glenway's brother Lloyd, and Lloyd's wife, Barbara Harrison—a triangular formation that mirrored the emotional intensity of the love triangle represented in the novel. Given the realities of Glenway's personal life with Wheeler and Lynes, however, the triangularity of the characters of *Pilgrim Hawk,* and the motif of the bird of prey more accurately relate to Wescott's longing for the past, the expatriate years he shared most intimately with his two loves.

Whatever the relationship of *Pilgrim Hawk*'s characters was to Wescott's emotional struggles, shortly after its publication he found his prey, first in Charles Rains and later in Henry Nelson Lansdale—men whom he substituted for his current sexual failure with Monroe and George. In his journals of this period, Glenway wrote of "the awful dependence of middle-aged men upon young men whom they have no respect for, and vice versa."[6] In retrospect, the mid- to late thirties was for Wescott a period of self-pity, but eventually he overcame his inability to write, and in 1939 he completed *The Pilgrim Hawk* to great acclaim. According to Jerry Rosco, "The short novel was published almost as soon as Wescott finished it."[7] The story was serialized in the November and December issues of *Harper's* magazine, shortly before Harper and Sons released the first hardcover edition in 1940. Even though its first edition sold slightly more than two thousand copies, *The Pilgrim Hawk* has remained a classic. In 1946 it was reprinted in the Dial Press anthology, *Great American Short Novels,* and in 1954 Dell Publishing included it in the anthology *Six Great Modern Short Novels.*

While Glenway had been struggling a great deal since his return to New York City in 1934, his and Wheeler's protégé, George, was coming into his own as a serious photographer. The period 1932 to 1936 was most important to George's emerging career. Judging from his correspondence of this time, gone were the insecurities and awkwardness of a young man uncertain about his place in life or the role he would

play in the ménage he shared with Wescott and Wheeler. Having dropped out of Yale in 1926, George had made a clear break from any sort of conventional way of life. With Monroe's and Glenway's encouragement he had taken up photography as an art form and as a means to eventually make a living. By 1932 his tenacity and ambition had begun to pay off as those with influence in the art world took notice of his work.

An important acquaintance of both George Lynes and Walker Evans was Lincoln Kirstein, an icon of twentieth-century art and culture, whose vast influence is still being sorted out. Lynes had known Kirstein as a boy, when the two met in 1923 at the Berkshire School. The two met as boys while participating in the school's camera club and working on its literary magazine, *The Dome.* But it wasn't until both men were adults, living in New York, that they became close associates. Not unlike a number of artists of this generation in New York, George was a beneficiary of Kirstein's influence when the latter moved to the city in 1931. Kirstein's involvement in jump-starting MOMA and in the New York art scene in the early thirties cannot be overestimated, especially as it relates to George's emerging career.

George Platt Lynes, *Landscape*, photo-mural, 1932.

Before landing in New York, Kirstein had already made a splash at Harvard, where he formed the pioneering Society of Contemporary Art, whose groundbreaking exhibitions were a key influence on the Museum of Modern Art. After moving to New York, Kirstein became a regular trustee at MOMA, as well as secretary and trustee of MOMA's recently developed film library. Kirstein was at this time also beginning to exercise significant influence over the exhibition program. In 1932 he organized MOMA's first exhibition to feature photography, "Murals

by American Painters and Photographers," which included work by sixty-five artists, including Lynes, Bernice Abbott, and Edward Steichen.[8] Although the exhibition was deemed controversial due to the political content of one of the photomurals, for George it was simply great exposure for his talents. Lynes's work in the exhibition was "Landscape," an ambitious colorized mural that featured two male nudes overlaid in a double-exposure-like fashion. Measuring some eight feet by sixteen feet, the mural melded antique and modern motifs in a composition that beautifully represented George's artistic and erotic interests and pointed to his later work with the male nude, work that would mark the greater portion of his output after 1940.

Russell Lynes wrote that his brother George, "rode high from the 1930s into the 1940s. Professionally and emotionally he had matters in hand, and there seemed no threats to the continuance, indeed the embellishment, of his career...no threats, as he recognized, except his inability or unwillingness to manage his business affairs. His personal affairs were complex; he would not have wanted them otherwise."[9] As many have pointed out, George was accustomed to an extravagance that too often outpaced his income. Were it not for the organizational help of his assistant Dora Maxwell the financial troubles that plagued him later in life would most certainly have arrived sooner. Dora began as George's temporary assistant, and the photographer quickly realized she could facilitate all day-to-day operations. For eight years Dora made prints in the darkroom, scheduled George's appointments, booked the models, and paid the bills. She saw to it that Lynes followed through on commitments and was informed about the studio's finances.

George Platt Lynes, *Male Nude*, c. 1934.

According to Russell Lynes, between 1935 and 1937 George "was busier than he had ever been and there seemed to be no reason why the demands on his

talents should not continue to increase, as they seemed to have, by geometric progression. As his business expanded so did his appetites — for more space in which to

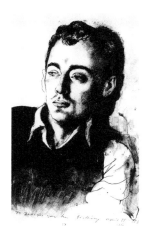

work, more assistants to help him (as you would expect), and a handsomer and more luxurious setting in which to be admired by friends and with which to impress his clients."[10] It was "good business," the photographer once declared. In reality, however, the increasing overhead was also for his own amusement and ego. During this time George was working steadily for *Harper's Bazaar* and *Vogue*, as well as taking on numerous commissioned portrait sittings of New York's elite. Burning the candle at both ends, Lynes was also using the studio at night, shooting male nudes of friends and dancers, creating pieces that were "personal" and not yet known to the public. The studio was "fraught," as the photographer declared.[11]

Pavel Tchelitchew,
Portrait of George Platt Lynes,
ink on paper, 1935.

Still relatively young, in good spirits, and up to the tasks of being a professional, Lynes was finally being recognized as an individual and not as Wescott and Wheeler's "boy." He had longed for this since dropping out of Yale and beginning work in photography. Lynes had grown up. As he wrote to his brother Russell from Paris in February 1937: "Not like the good old days, when for hours and for my own pleasure I typed weird communications to one and all, all and sundry."[12] While working on fashion trips to France, Lynes reconnected with those he had met earlier with Monroe and Glenway: Jacques Guérin, Pierre Roy, André Durst, Jean Cocteau, Marcel Khill, and Eardly Knollys. George was no longer just cavorting with the smart crowd of Europe, he was actively working and making a fine living as a photographer. As he wrote his brother: "I have not stopped working a minute, to some purpose and considerable effect, and am pleased. Today, for example, I have a sitting at noon and one at six. At least a half dozen dresses at a sitting. Probably about eight hours of work."[13] During this time fashion work still held interest for Lynes; later, in the forties and fifties, he lost interest in it altogether. The work and

the experience of this period, as we shall see, would pay off for the photographer in a number of respects.

In 1935 Wheeler commenced his long association with the Museum of Modern Art, which had been founded only six years earlier. Of all three men's accomplishments in the thirties, perhaps Monroe's relationship with the budding museum was most auspicious. Having proven himself unique in the world of small presses, Monroe's ambition was to translate that experience. At MOMA he created opportunities to do just that, beginning with special exhibitions and assignments and later moving through a number of important staff positions. It was a unique situation that allowed him to build upon his experience while asserting himself in New York's bustling art world.

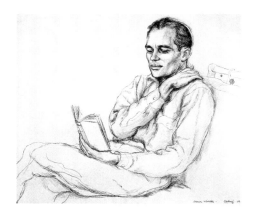

Paul Cadmus, *Portrait of Monroe Wheeler*, ink on paper, 1938.

While producing the deluxe Harrison of Paris editions, Wheeler acquired a reputation for his personal aesthetic. The Harrison of Paris books were, materially speaking, extraordinary. Monroe oversaw every detail from typography and overall design to folio paper and binding materials. He used Van Krimpen, the ancient firm of Enshedé of Holland, for typography and printing. This was the same foundry used by Des Esseintes in Joris-Karl Huysmans' novel *A Rebours* — not a strange coincidence given Monroe's aesthetic leanings. Special clients were the recipients of private editions that were produced by Harrison of Paris; Monroe contracted the famous Ignatz Wiemeler to bind copies with fine materials such as dyed morocco leather and cut Renaissance velvet. The Harrison of Paris books were infused with a sense of the decadent tradition in bookmaking; they referenced William Morris's Kelmscott Press and John Lane's Bodley Head in England, as well as Copeland and

Day and Stone and Kimball of Boston, both fine turn-of-the-century New England publishers. Harrison of Paris was a modernist enterprise, and while its books shared many material qualities with books created in earlier moments in publishing, they deviated significantly especially in their design. Monroe blended modern elements of typography and illustration with classic texts. He often commissioned leading artists to create drawings, for instance, Alexander Calder's line drawings to illustrate *Fables of Aesop,* or Pavel Tchelitchew's ink-and-wash studies utilized in Wescott's *Calendar of Saints for Unbelievers.*

Given his close publishing connections in Europe, it is not surprising, though quite significant, that the first exhibition Monroe mounted for MOMA was dedicated to Wiemeler's bindings. The exhibition, "Ignatz Wiemeler: Modern Bookbinder," which opened in 1935, was deemed innovative as well as a success. It was perhaps the first time that any museum had paid tribute to the art of bookmaking. The exhibition, and its accompanying catalog, allowed Monroe to showcase his talents and his aestheticism, which later proved invaluable to the museum. According to one account, the exhibition "came as a revelation to other, more established, museums and, for the first time in the United States, contemporary bookmaking was accepted as an art form."[14] The following year, 1936, Monroe mounted what he considered his most important contribution at MOMA, the exhibition "Modern Painters and Sculptors as Illustrators." The exhibition featured several books published by Ambroise Vollard, including Paul Verlaine's *Parallèment,* illustrated by Pierre Bonnard, which Wheeler considered "the most beautiful book of the twentieth century." Single-handedly, Monroe's work "inspired other forward-looking American museums to collect contemporary illustrated books."[15] Monroe's dedication to a nearly lost and obscure form of fine craftsmanship as relates to bookmaking was the keystone on which he would continue to develop his career as a connoisseur, curator, and publisher.

Monroe became a member of the museum's Library Committee in 1935 and of its Advisory Committee in 1937. Although he wasn't yet a full-time staff member,

he was familiar with the inner workings of MOMA and spent much of his social time with beneficiaries and decision makers. As a 1983 *Connoisseur* profile of Wheeler articulated, he "moved gracefully through a very grand world. With its atmosphere of political intrigue, the museum's behind-the-scenes drama rivaled the excitement created by the exhibits."[16] During this time Monroe was called upon to court various leading artists to consider exhibiting at MOMA. Among those to whom Monroe appealed were Pablo Picasso, Marc Chagall, and Henri Matisse. "If they need someone charmed," Russell Lynes recounted in his 1973 book *Good Old Modern*, "they have Monroe to do it."[17] Although the challenges were many, Wheeler rarely displayed his anxieties or his perturbation while attending to museum affairs. In his journal entry of March 9, 1936: "Went to a Museum of Modern Art Committee meeting — thoroughly obnoxious to me on account of Walter Chrysler, Jr. who hemmed and hawed most illiterately, and Russell Hitchcock, who brayed on and on with blissful self-satisfaction. I should have left if I had not been down to give an account of my show." Face-to-face, Monroe always demonstrated that he was a gentleman, a diplomat, and an advocate of political compromise. These qualities were constantly called upon to win over the disparate egos and agendas that sought to direct the course of the museum.

Wheeler became a full-time staff member in 1938 when he was hired as director of membership. Finally, in 1939, after many years of supporting the MOMA, he was named director of publications. It was in this position that Monroe utilized his vast knowledge of bookmaking in a modern publishing program. A 1964 *Apollo* magazine profile of Wheeler stated that "he . . . literally transformed the image of the modern art book, owing to his astute knowledge of typography, lay-out, reproduction techniques, and fine art printing. Under his directorship, a Museum of Modern Art publication has come to mean the highest standard in art-book production."[18] During his tenure, which lasted thirty years, Monroe oversaw the publication of more than 350 books on the visual arts. Of these, many were highly acclaimed and more than a few received distinguished awards for their design. Wheeler produced

acclaimed retrospective books on Chaim Soutine, Georges Rouault, Henri Matisse, Pierre Bonnard, and J.M.W. Turner.

While the threesome embraced the professional opportunities before them, they still shared a vivid life together, even if there were occasional emotional struggles, discord, and even jealously from time to time. At the East Eighty-ninth Street apartment George and Monroe shared one bedroom, while Glenway occupied another by himself. During this time, and throughout the thirties, all three men, while having very different social agendas, were frequently seen together, whether dining at the St. Denis with friends visiting from Europe, frequenting the ballet, or attending cocktail and dinner parties. Their recorded social engagements, often noted in George's letters and in Monroe's journals, were a virtual *Who's Who* of New York's artistic and literary community. Wheeler recorded on Wednesday, October 28, 1936: "Cocktail party for Katherine Anne Porter. Carl van Doren came with Jean Wright, also Kenneth Durant and his wife, Genevieve Taggart and the latter's sister, Hildegarde; Thomas Mann's daughter and son, Erika and Klaus; Malcolm Cowley, our old friend, Toni Salemmi; Katie Sachse, here again on a mission for the Italian Government; Ted and Ann Hatfield; Josephine Herbst; Lincoln Kirstein; Tom Mabry; Muriel King; Ruth Elizabeth Ford; the Askews, and Denham Fouts." George went even further, recording in his journals the drinks and the meals—down to the last potato—he served his guests. He wouldn't have dared to serve a guest the same dish twice.

An example of their shared social life is underscored in the snapshots of 1936, on the occasion of the threesome's reunion with Jean Cocteau, Marcel Khill, and Cecil Beaton. That year Monroe recorded in his journal that "We took Cocteau to lunch at the Rockefeller Grill, and he was ecstatic about the ethereal laciness of New York, saying that he had always thought that it would be a heavy, cumbersome place." Showing their guests around Manhattan thrilled George, Monroe, and Glenway. Their amusement is wonderfully captured in a photograph taken at Coney

Island, in which George is clowning around for Monroe's camera as Beaton, Cocteau, Glenway, and Khill surround the scene in bemusement. Monroe recalled that "We all dined at our house and afterward met Cecil Beaton at Minsky's Burlesque, which fascinated Cocteau.... Afterward we got in an open car and motored around the waterfront, through Wall Street.... We stopped beside a tenement, an iron fire escape zig-zagging, to which Jean exclaimed 'It's like lightning.'"

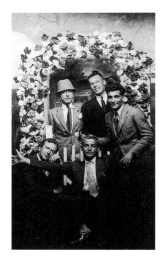

Front: Cecil Beaton and George Platt Lynes. Rear: Jean Cocteau, Glenway Wescott, and Marcel Khill, Coney Island, 1936.

On weekends, or when time permitted, the three retreated to a farm estate they called Stone-blossom.[19] Located near the Mulhocaway River in western New Jersey, the house and the property of Stone-blossom were given to the three in 1937 by Lloyd Wescott, Glenway's younger brother, and Barbara Harrison. The farm and the grounds around it were the site of many gatherings, festive dinners, and nature outings. For all three men, the tension between city life and the contemplative New Jersey countryside was a constant source for inspiration. Stone-blossom became the perfect hideaway of which the harried New Yorker is forever in search. Writing in his journal in June 1939 Wescott declared: "This week I stayed on at Stone-blossom by myself Monday and Tuesday. I love it so, even when it signifies family fuss more than anything else; even when it makes me all emotional and fidgety, as Wisconsin did in my boyhood."[20]

Of the frequent visitors to Stone-blossom, none were closer to the threesome than artists Paul Cadmus, Jared French, and French's wife Margaret, the group collectively known as PAJAMA. Like Wheeler, Wescott, and Lynes, they too found inspiration in the luscious countryside as it was a place to commune with nature, draw, paint, or otherwise conceptualize the next piece of work. In several respects, the tri-

angularity of the PAJAMA group shared many similarities with the ménage à trois of Monroe, George, and Glenway. Cadmus and Jared French had met in the early thirties while both men were taking classes at the Art Students League. Shortly thereafter the two became lovers and like many of their friends, departed for Europe where they could live cheaply while developing their art. Returning to New York in 1933 to join the Public Works of Art Project, Cadmus and French shared apartments, first in Greenwich Village and later an apartment Cadmus occupied until 1960 at Five St. Mark's Place. Meeting Lincoln Kirstein around 1933, it was but a short time later that they were introduced to George, Monroe, and Glenway.

PAJAMA, *George Platt Lynes*, Fire Island, c. 1940.

In 1937 Jared met and fell in love with Margaret Hoening, thus ending the exclusive relationship he had with Cadmus. Accepting Jared's bisexuality, Cadmus acquiesced and for several more years he and Margaret shared Jared as their lover. As PAJAMA French, Cadmus, and Margaret were known as an artist collective that utilized photography. Together they often photographed themselves and friends frolicking on the beach at Fire Island, or at Lynes, Wheeler, and Wescott's Stone-blossom farm. According to one scholar's account, "Merging the human body with the forms of nature and architecture, the PAJAMA pictures describe a remote, timeless world that serves as a model and inspiration" for French's paintings.[21] Glenway's journals from this time point to the active friendship the six individuals shared while together. In February 1940 he wrote that "George had had practically nothing to eat and somewhat too much to drink, and came home loud, grandiosely fond, absurdly lovable. We hobnobbed with Paul and the French's all sweetly cooing, a dovecot in tweeds."[22]

Perhaps nothing underscores the harmony of our triumvirate at this time more than Paul Cadmus's 1940 painting, *Conversation Piece*, for which a number of masterful drawings exist. In it, Cadmus created a triangular composition that shows Monroe, Glenway, and George lounging beneath an old and withered oak tree before the Stone-blossom farmhouse. In the background a man is cutting the grass.

It is a warm day, George wears a swimsuit, and Monroe is without a shirt. With newspapers and magazines strewn about the scene, Cadmus caught something of each man's mien: Wheeler in studied concentration; Lynes staring blissfully out of the picture plane; and Wescott, seeming somewhat dismayed, with one hand on a hip and the other holding a cigarette. *Conversation Piece* shows the

Paul Cadmus, *Conversation Piece*, graphite and ink on paper, 1940.

maturity of the relationship, the comfort and easygoing nature that presumably held these men together for so long. It is curious that Cadmus placed Glenway in the center. Perhaps this was due to the farm originating from his family, or perhaps it has to do with the way Cadmus perceived Wescott's emotions as a man in the middle, a third wheel as it were.

Insofar as bisexuality had been an issue for Cadmus and French, it had manifested in a taboo-free environment, where judgment and scorn were rarely exercised by friends. In public, however, discretion was advised, especially to an American public that deemed anything but prescribed heterosexuality as abnormal and immoral at this time. The kind of omni- or pansexuality that this generation experimented with was part of an overall attempt to free oneself from strictures and societal norms. Notwithstanding the real presence of many committed homosexual relationships in

this social circle, there was an openness and tolerance to other forms of sexual expression, especially since Wheeler, Lynes, and Wescott all shared such complex pasts; all three men at one time or another had intimate, if not sexual, relationships with women. On the part of the two older men, bisexuality had more to do with societal pressure, homophobia, and the real fear of a hostile world's perception of two men in love; these may have been the factors that drove Wheeler's fascination with Elly Ney or Wescott's "platonic" relationship with Kathleen Foster. In the case of the younger Lynes, however, it would appear to be more a matter of pure sexual appetite and the photographer's willingness to please his many female admirers. The omnisexuality that sometimes characterized Lynes's behavior was in any case not something he openly shared with Wheeler or Wescott, although they were cognizant of his dalliances. To be sure, these marked the beginning of a troublesome time for the threesome, especially as Monroe and Glenway struggled to understand George's actions.

In 1938 George "discovered" Laurie Douglas, one of the models he employed repeatedly for fashion shoots and in female nude compositions from the late thirties and through the forties. Dougie, as she was affectionately called, possessed exquisite beauty, a full-figured body that George recognized immediately as model material for his expanding studio. Dougie and George became close friends, and even though she thought, as did numerous other women, that Lynes was extremely handsome, by her own account she "could never conceive of making a pass at a homosexual."[23] George obviously felt otherwise about making passes at straight women. He told Dougie of "other flings he had with women—one an older friend whose husband had treated her badly and he felt sorry for. The other, a young girl who was mad about him and he couldn't resist—but became disenchanted when she started to moon around and get serious."[24] Compared to these earlier "flings" with women, however, George's relationship with Dougie was intense and presumably sexually satisfying. It started as a sexual fling and evolved into an ongoing affair, but this relationship did not prevent Lynes from sleeping with men. Notwithstanding this fact, Lynes felt possessive of Dougie: "On the nights [he] had

business dinners he made sure he knew where [she] was."[25] He bought Dougie a Cartier ring, gold earrings made by Fulco, and an East Indian nose ring. When George met Jonathan Tichenor—with whom his relationship eventually wrecked the ménage he shared with Monroe and Glenway—he began treating Dougie badly. According to Dougie, the sexual relationship ended when "George started to make remarks in front of his male friends that...'he didn't want his boy friend making passes at his girl friend.'"[26] The complexities of George's personal affairs would be a source of consternation for Monroe and Glenway from this point forward. However, both men would continue to vigorously support George and to open new doors for the young artist.

This is most apparent with the variety of roles that Monroe continued to play at the fledgling Museum of Modern Art. From the moment he became associated with MOMA, Monroe made himself indispensable to the institution. As a curator and publisher, his tasks were multifaceted, but it was as spokesperson and emissary that he shined brightest from the mid-thirties throughout the forties. Always eager to employ his European connections on behalf of the museum and his close friends, Monroe assisted a number of MOMA's principals during the planning and organizing stages of several exhibitions. His influence was not unuseful to George, who was still attempting to assert himself as a leader in the New York photography scene.

Of the most influential and groundbreaking exhibitions of this period must be counted Beaumont Newhall's survey, "Photography: 1839 to the Present," mounted between March 17 and April 18, 1937. In a journal entry from this period Monroe wrote that "I lunched with Beaumont Newhall, who has just returned from Europe where he has been organizing the big exhibition on photography which the Museum of Modern Art will hold in early spring.... Newhall also met Fox Talbot's granddaughter at Bath, and got a large collection of Fox Talbot prints in his show. He said my letter to Charles Peignot [editor and publisher of *Arts et métier graphiques*] had been extremely helpful to him and enabled him to meet all the fanatic French

collector's of early photographs." Actions such as Monroe's helped facilitate the tremendous success that exhibitions like Newhall's had enjoyed. The exhibition catalog was later revised and published as a book by the museum in 1938. In his memoirs, Newhall recalled that it was Wheeler who, in 1947, suggested that *Photography: A Short Critical History,* the subsequent book based on the exhibition, be printed with the title *The History of Photography,* a book that has for years been indispensable to scholars and students of the medium.[27]

Newhall wrote that "One of the people at the museum for whom I had always had tremendous respect was the director of the publications department, Monroe Wheeler. A man of enormous intelligence and talent, in his own quiet, behind-the-scenes way he had been the virtual director of the museum."[28] It was this kind of respect that allowed Wheeler to intercede on behalf of his talented friends, including George Platt Lynes. In a journal entry of 1936, this kind of action is made clear: "Beaumont Newhall came to dinner with George and myself. George, exhausted by a long *Harper's Bazaar* sitting, was very poor company, indeed. I showed Beaumont many of George's photographs, because he is the director of the big photograph show that the museum is going to hold next spring, and he professed to like some of them extremely." Not to detract anything from George's true talents as a photographer, between Lincoln Kirstein, and his lover, Monroe, Lynes had influential friends at MOMA. Newhall selected four of Lynes's images for his 1937 exhibition, and one, a portrait of Cocteau, was reproduced as a full page in the exhibition catalog.

Notwithstanding his early involvement with MOMA, Lincoln Kirstein was now firmly associated with the development of ballet in America, his greatest love of all the arts. In 1933 he was instrumental in bringing Russian-born George Balanchine to the United States, and it was but a short time thereafter that Lynes was commissioned to photograph Balanchine's principal dancers. Lynes excelled at dance photography, and the earliest of his ballet pictures demonstrate his innovative lighting techniques

and fluid posing. It was from the various ballet companies — American Ballet, Ballet Caravan, Ballet Society, and later the New York City Ballet — that George selected models for his more personal work with the male nude. The dancers intrigued George, not only for their muscularly toned bodies but for their near effortless movements. In many of the male nudes taken from this period we recognize some of the great dancers associated with Kirstein and Balanchine, including Lew Christensen, Eugene Loring, and Herbert Bliss. Many of Balanchine's principal dancers became George's lifelong friends, and it was through their creative work that he was to extend and refine his own approach to representing the male body.

George Platt Lynes, *Portrait of Lincoln Kirstein*, 1948.

During the mid- to late forties, Kirstein's support offered George new opportunities to exploit his innovative skills. One of the most remarkable events of that time took place in 1934, when the operetta *Four Saints in Three Acts* was performed at the Wadsworth Athenaeum in Hartford. George's photographs of Frederick Ashton, the choreographer, and his principal performers underscore the role that performance and dance would now play in his repertoire. They also suggested that Lynes was now being recognized and accepted into the rarefied literary and artistic circles of this important period of American culture. A collaboration between composer Virgil Thomson and Gertrude Stein, the operetta was based upon Stein's two favorite saints, Teresa of Avila and Ignatius Loyola, and dealt with "religious life — peace between the sexes, community of faith, the production of miracles." Utilizing an all-black cast as specified by Thomson, the operetta signaled a break with traditional musical performances, defying many stereotypes about black singers and performers in traditional Western productions. *Four Saints in Three Acts*

brought together the creative energies of numerous cultural personalities, including John Houseman, the director, and Florine Stettheimer, the set designer.

Between 1937 and 1940 Glenway encouraged George to take up mythology as his subject matter. Not unlike one of his photographic predecessors, F. Holland Day, Lynes used the myths of Pan and Orpheus, Boreas, Ascaluphus, and the Birth of Dionysus as backdrops to his intensified interest in representing the male nude. Mythology, as Glenway put it in 1939, was simply a veil for George's interests to photograph the "most handsome young men . . . of the day more or less naked."[29] While pursuing the mythological series, George's studio was reaching its pinnacle of production. As his contacts in the fashion world expanded, he befriended many notable personalities with whom he worked and occasionally entertained. Russell Lynes described George's situation this way: "Editors by and large, while more important to his financial welfare, were less important to him as friends. There were, to be sure, exceptions."[30] Such exceptions included Alexie Brodovitch, art director of *Harper's Bazaar*, and Barry Lowman, a fashion editor at *Vogue*. George also kept company with many of his favorite models of this period. In addition to Dougie there were Elizabeth Gibbons, Ruth Ford, Lisa Fonssagrives-Penn, and Betty McLaughlin, all of whom later recounted their pleasure in having worked with George.

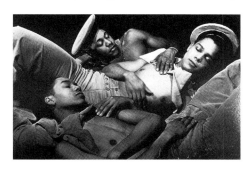

George Platt Lynes, Principal Performers, *Four Saints in Three Acts*, 1934.

At the beginning of the 1940s Glenway, Monroe, and George seemed to have settled into their lives as partners, lovers, and friends. This is not to say, however, that there weren't many trials, disappointments, and occasional periods of emotional discord. Having been together for nearly fifteen years, the threesome remained conjoined as

a result of the support that each man had given to the relationship. But this would soon change as World War II approached when George challenged the ménage with his personal financial stress as well as with his decision to take another lover. From this point forward George seems to have often been in debt and lacking the cash flow to service it. But this didn't keep him from pushing his talents to the limit or doing the best job that he could to keep the studio in operation. Fearing that he may be drafted for the war, George ambivalently sought a commission as a navy photographer. In April 1942 George wrote to his mother, Adelaide: "I am relieved . . . especially relieved of the horror of bankruptcy and of starting life all over again. If I can get over this feeling of exhaustion, if and when, I'll be a better man than I've been just lately."[31] George later told his brother Russell that he was excused from the navy as a "professed homosexual." During the war Monroe was in charge of publications in Washington, D.C. under Nelson A. Rockefeller while, for his part, Glenway was still riding high on the success of *The Pilgrim Hawk.* In 1940 Glenway's libretto for the ballet *The Dream of Audubon* appeared in *Dance* magazine and later in *The Best One Act Plays of 1940.* As World War II progressed, Glenway began work on his second best-selling novel, *Apartment in Athens,* which was published in 1945.

Sometime during late 1939 or early 1940, George became enamored of his studio assistant, George Tichenor. According to Russell Lynes, "Tichenor had come looking for a job at George's studio. . . . George hired him (he had been trained at the Clarence White School of Photography), and fell in love with him."[32] Tichenor worked for George until the former enlisted in the British American Ambulance Corp. He was later killed in the line of duty during the summer of 1942 at Bir Hascheim. This tragedy shocked George — it may even account for his waning interest in studio work and his ambivalence about continuing as a professional photographer. In any case, the event was a turning point both professionally and personally for George, and it would later have a profound impact on his relationship with Monroe and Glenway, with whom he was still sharing the East Eighty-ninth Street apartment.

Around this very time, Monroe was organizing for MOMA a major painting exhibition of Pavel Tchelitchew, an artist the threesome had known since their days together in France. According to a letter George sent to his mother, "Monroe, who has been trying for three years, has finally persuaded his trustees to put on the big Tchelitchew show in October, and we are all very excited about it."[33] For years the threesome and Lincoln Kirstein had been championing Tchelitchew's eerie combination of expressive line and tactile painterly technique. All of them had at one time or another sat for portraits by Pavlik, a fine example being the masterful ink-and-gouache portrait study of George given to him as a present from the artist for his twenty-eighth birthday in 1935.

The Tchelitchew exhibition in many ways was symbolic. It served to remind the threesome that they and many of their colleagues from the twenties had pursued their dreams and aspirations and that their careers and lives were now shaped with age. There had been many experiences between them, many successes, such as Monroe's MOMA exhibitions, George's 1941 retrospective at the Pierre Matisse Gallery, and Glenway's *Pilgrim Hawk*. There had been challenges as well, including George's flings with women, his love for and loss of George Tichenor, and his inability to pay his bills. But nothing so challenged the threesome as George's sudden departure from the East Eighty-ninth Street apartment he had shared for years with Monroe and Glenway. This marked the beginning of the end of their marvelous ménage and the "family" experiment they had been conducting since the early thirties.

On February 27, 1943, George wrote his mother, Adelaide, about his abrupt decision to leave the apartment he shared with Monroe and Glenway: "There really isn't any explanation, there certainly isn't any quarrel or misunderstanding, but it seems only right and proper to let you know that I've decided to go off and live by myself and have been flat-hunting for the past three days. Mon has wanted for some time to live nearer the museum and in a place where he could entertain trustees, visiting museum directors, and the like, and will take a place himself. Glen may go to Stone-blossom or he may stay in Eighty-ninth Street. They are both away at the

moment, visiting Willie [William Somerset] Maugham, so I cannot properly answer for them. And I'll let you know where I settle . . . I'll decide next week."[34] George had decided to leave Monroe and Glenway without telling them in advance. While they were away visiting Maugham, George leased 421 Park Avenue, a place that, by Russell Lynes's account, "suited him, it pleased his friends, it lent itself to the changes he continually liked to make in the details of his surroundings."[35] The greatest change that George had recently made, however, would not please Monroe or Glenway.

After Tichenor's death, George hired Tichenor's brother Jonathan, a confused young man who appeared to many in Lynes's circle both "pliant" and on the make.

Like his own mentors, Glenway and Monroe, it was George's pleasure to bring a young, unsophisticated, or little-experienced person into his world and introduce him to culture and to George's refined lifestyle. In 1943 this is precisely what happened. This is what precipitated George's moving out of the East Eighty-ninth Street apartment, but he would only reveal this, his true motivation, to Monroe and Glenway much later.

Having become infatuated with the younger Tichenor, George again fell in love, offering Jonathan his new Park Avenue flat as a place to live. Jonathan also was brought into the studio to

George Platt Lynes, *Portrait of Jonathan Tichenor*, 1945.

train as an assistant and as a photographer. George began to brag about his new lover, his new boyfriend, showing him off to visitors to the studio and slowly introducing him to his old friends. It appeared as a sudden, reckless change to many of George's close friends and family, but it was devastating to Glenway and to Monroe especially. They had had no idea about George's new love interest. Having endured this type of episode earlier in his life, Monroe felt betrayed, a sense of loss, and

heartbroken. Shortly after George's departure, Monroe met with Russell Lynes to possibly better understand George's actions. As Russell recalled: "Monroe was not just puzzled, he was severely hurt by George's abruptly and unilaterally deserting, as Monroe saw it, his 'family,' turning away from his two most concerned friends who had so assiduously guided and promoted his career, and one of whom was his intellectual lode star and the other his longest, dearest love."[36]

In February 1943, Glenway, perhaps more able to understand George's actions than Monroe, wrote Barbara Harrison a detailed account of the situation. "I am glad it is all settled for George's sake," Glenway wrote. "For four years, he has been spellbound, discontented with his life, dissatisfied with himself: afraid of the future, sick of the past, changing his mind all the time, in no way or another not sober, breaking his promises to himself, unable to promise anyone else anything, bored and sad — and he could not help it."[37] Glenway tried to see the situation from George's perspective, but he also knew that Monroe had been most patient with George, and his simply leaving without notice could have all been avoided had George the requi-

site courage to discuss it with Monroe. In a letter written to George on March 3, 1943, Glenway suggested to George that he had underestimated Monroe's feelings and his level of patience, telling George he "lacked imagination," the ability to "put [himself] in another's place."[38] "I do understand you yourself," Glenway continued. "I believe; and I understand about loving Monroe: the fact that you have not ceased loving him, and the fact that you cannot love him in the old way. Your love of Jonathan is stronger, though perhaps lesser; which is perfectly simple, and could not be helped."

George Platt Lynes, *Portrait of Glenway Wescott*, c. 1937.

Though Glenway would continue to see George throughout the rest of George's life, Monroe broke off contact with him for some time. Their friendship, in many ways, was never reconciled, though both men's

circles were so tightly intertwined, especially with family and art world connections, that they often saw each other. The breakup of the ménage also had been embarrassing to Monroe, who for years had walked a tightrope with his MOMA colleagues, trustees, and patrons. Homophobia was still a grim reality, and all three men had been most discreet in the company of art world society. Although the ménage à trois had never been a secret to anyone close to the three, Monroe feared the breakup would raise eyebrows. As Glenway once declared, "there's strength in numbers."

At this point, Glenway moved permanently to Stone-blossom and Monroe took an apartment in midtown near the museum. In all respects *their* friendship remained strong — they had weathered many storms together since their meeting in the 1910s. The two were lifelong intimates until their deaths, Glenway's in February 1987 and Monroe's in August 1988. After 1943, both men's careers were marked by major achievements. Glenway finished *Apartment in Athens* in 1945. Although his last long work of fiction was criticized for being too didactic in its anti-Nazi position, *Apartment in Athens* became a best-seller. In 1962, Glenway published *Images of Truth*, a collection of "eight long, highly impressionistic critical essays about six writers — Katherine Anne Porter, Somerset Maugham, Colette, Isak Dinesen, Thomas Mann, and Thornton Wilder." From 1959 to 1962 he served as president of the American Academy of Arts and Letters. While he published little during the last twenty years of his life, Glenway did keep a journal from which this book has benefited.

Monroe continued on at MOMA until his retirement in 1966. In 1945 he was made Trustee, in 1966 Honorary Trustee for Life, and in 1967 he was made Counselor to the Board of Trustees. Monroe's most scholarly contribution was his monograph and exhibition of 1950 on Chaim Soutine, the first in-depth study of that artist's work.[39] Some of his most acclaimed exhibitions were "The Last Works of Henri Matisse" and a "Pierre Bonnard: A Retrospective." Monroe served many organizations after 1950, including his membership on the Publications Committee of UNESCO (United Nations Educational, Scientific, and Cultural Organization),

Paris, and on the Visual Arts Advisory Committee of the Center for Inter-American Relations. He was also a trustee of the American Institute of Graphic Arts, of the Katherine Anne Porter Foundation, and of the Ben Shahn Foundation. In 1950 Monroe received the Order of the Chevalier of the French Legion of Honor in recognition of "his outstanding services to the cause of French contemporary art in the United States." Shortly before his death in 1988, he was honored by MOMA with the dedication of the Monroe Wheeler Reading Room in the Prints and Illustrated Books Galleries.

Lynes's career had begun to unravel after the older Tichenor's death. With the distractions of his new boyfriend, and his new life on Park Avenue, his career in New York deteriorated throughout the rest of the forties, though it was not until the early fifties that he was essentially finished as a professional photographer. The singular event that sealed this fate was his decision to move to Los Angeles to work in the *Vogue* studios in 1946. Cecil Beaton prophetically recorded in his memoirs that Lynes's "emigration to [California] has not yet benefited his work. In fact, his friends are worried; the move from east to west may prove disaster."[40] In Los Angeles Lynes fell further into financial distress, relying upon a salary that was meager by comparison to his freelance fees in New York. His extravagant lifestyle, and over the top spending on a Hollywood Hills residence, quickly depleted his resources. Forced to move back to New York in 1948, Lynes realized he had sacrificed his share of the ever-changing fashion and commercial photography market that was now dominated by younger photographers such as Richard Avedon and Irving Penn.

Lynes declared bankruptcy, in 1951. He narrowly escaped a second filing in 1954. During this time he had begun to supplement his income with print sales of the male nude to Dr. Alfred Kinsey, whose immense archive now houses the largest institutional collection of Lynes's work. Kinsey was fascinated with the male nudes, believing to some extent that they offered visual "proof" of homosexual eroticism, a topic he and his researchers continued to investigate since their

291

landmark publication, *Sexual Behavior in the Human Male* (1948). For Lynes, the print sales to Kinsey were financially beneficial, but they did not forestall his eventual withdrawal from New York, an event precipitated by his recent diagnoses of lung cancer. Retreating to the family home in North Egremont, Massachusetts, Lynes's condition quickly deteriorated. With the help of friends, he made one last trip to Paris in the autumn of 1955. Returning to the United States in November of that year, Lynes died a month later in New York on December 6, 1955. He was forty-eight years old.

James Crump

Endnotes

1. Jerry Rosco, "An American Treasure: Glenway Wescott's The Pilgrim Hawk," *Literary Review* (Winter 1988), pp. 133–142.

2. Glenway Wescott, *Continual Lessons: The Journals of Glenway Wescott.* Edited by Robert Phelps with Jerry Rosco (New York: Farrar, Straus & Giroux, 1990), p. 20.

3. Ibid., p. 17.

4. Ibid., p. 10.

5. Rosco, p. 135.

6. Wescott, p. 74.

7. Rosco, p. 140.

8. Christopher Phillips, "The Judgment Seat of Photography," *October* 22 (Fall 1982), pp. 27–63.

9. Russell Lynes, *George Platt Lynes: A Biography,* Unpublished Manuscript, Chapter Seven, p. 1.

10. Ibid., Chapter Seven, p. 2.

11. Ibid., Chapter Seven, p. 1 and p. 9.

12. Ibid., Chapter Seven, pp. 1–2.

13. Ibid., Chapter Seven, p. 2.

14. "Monroe Wheeler: A Profile," unsigned article, *Apollo* (June 1964), p. 112.

15. Ibid., p. 113.

16. Elisabeth Wynhausen, "The Persuader: A Great Museum's Hidden Asset is Monroe Wheeler's Prodigious Charm," *Connoisseur* (October 1983), p. 108.

17. Russell Lynes, *Good Old Modern: An Intimate Portrait of the Museum of Modern Art* (New York: Scribner, 1981).

18. *Apollo,* pp. 112.

19. On Stone-blossom see Glenway Wescott, "The Valley Submerged," *Southern Review* (Summer 1965), pp. 621–623.

20. Wescott, *Continual Lessons*, p. 53.

21. Nancy Grimes, *Jared French's Myths* (San Francisco, Pomegranate Books, 1993), p. X.

22. Wescott, *Continual Lessons*, p. 65.

23. Russell Lynes, *George Platt Lynes*, Chapter Seven, p. 19.

24. Ibid., Chapter Seven, p. 20.

25. Ibid., Chapter Seven, p. 21.

26. Ibid., Chapter Seven, p. 21.

27. Beaumont Newhall, *Focus: A Memoir of a Life in Photography* (Boston: Bulfinch Press, 1993), pp. 176, 177, and 181.

28. Ibid., p. 153.

29. Glenway Wescott, "Illustrations of Mythology," *U.S. Camera*, No. 2 (January-February 1939).

30. Lynes, *George Platt Lynes*, Chapter Seven, p. 11.

31. Ibid., Chapter Eight, p. 10.

32. Ibid., Chapter Eight, p. 11.

33. Ibid., Chapter Eight, p. 14.

34. Ibid., Chapter Eight, pp. 20–21.

35. Ibid., Chapter Eight, p. 23.

36. Ibid., Chapter Eight, p. 20.

37. Wescott, *Continual Lessons*, p. 107.

38. Ibid., pp. 108–110.

39. Monroe Wheeler, *Chaim Soutine* (New York: Museum of Modern Art, 1944).

40. Cecil Beaton, *Memoirs of the Forties* (New York: McGraw-Hill, 1972), p. 294.

Selected Bibliography

Aloff, Mindy. "George Platt Lynes." *Dance Magazine* 56 (April 1982): 46–49.

Baldwin, Neal. *Man Ray: American Artist.* New York: Clarkson N. Potter, Inc., 1988.

Bawer, Bruce. "Glenway Wescott, 1901–1987." *The New Criterion* 5, no. 9 (1987): 36–45.

Beaton, Cecil. *Memoirs of the Forties.* New York: McGraw-Hill, 1972.

Blondel, Nathalie. *Mary Butts: Scenes from the Life.* New York: McPherson and Co., 1998.

Crump, James. *George Platt Lynes: Photographs from the Kinsey Institute.* Boston and Toronto: Bulfinch Press, Little, Brown and Co., 1993.

Gado, Frank, ed. *First Person: Conversations on Writers and Writing with Glenway Wescott, John Dos Passos, Robert Penn Warren, John Updike, John Barth, and Robert Coover.* Syracuse: Syracuse University Press, 1974.

Byron, Lord. *Childe Harold's Pilgrimage,* with twenty-eight wash drawings by Sir Francis Cyril Rose. Paris: Harrison of Paris, 1931.

Dostoevsky, Fyodor. *A Gentle Spirit: A Fantastic Story,* translated by Constance Garnett, with a frontispiece and tailpiece by Christian Bérard. Paris: Harrison of Paris, 1931.

"Ein Meister der modernen Photographie." *Der Kreis,* Zurich (July 1950).

Ellenzweig, Allen. *The Homoerotic Photograph.* New York: Columbia University Press, 1992.

Emory-Hulick, Diane. "George Platt Lynes: The Portrait Series of Thomas Mann." *History of Photography* 15, no. 3 (Autumn 1991): 211–221.

Ebria Feinblatt. *Seventeen American Photographers.* Los Angeles: Los Angeles County Museum of Art, 1948.

Fables of Aesop, with fifty drawings by Alexander Calder. Paris: Harrison of Paris, 1931.

Fischer, Hal. "George Platt Lynes: the Book." *Advocate* 332 (December 10, 1981): 23.

Fondiller, Harvey V. "Mythological Images by George Platt Lynes." *Popular Photography* 89 (January 1982): 11–12.

Ford, Hugh. *Published in Paris: American and British, Writers, Printers, and Publishers in Paris, 1920–1939.* New York: Macmillan Publishing Company, 1975.

———. *Four Lives in Paris,* with an Introduction by Glenway Wescott. San Francisco: North Point Press, 1987.

Givner, Joan. *Katherine Anne Porter: A Life.* New York: Simon and Schuster, 1982.

Grimes, Nancy. "French's Symbolic Figuration." *Art in America* 80, no. 11 (November 1992): 110–115.

Hall-Duncan, Nancy. *History of Fashion Photography.* New York: International Museum of Photography, Alpine Books, 1977.

Hambourg, Maria Morris, and Christopher Phillips. *The New Vision: Photography Between the World Wars,* Ford Motor Company Collection at the Metropolitan Museum of Art. New York: The Metropolitan Museum, Harry N. Abrams, 1989.

Harrison, Martin. *Appearances: Fashion Photography Since 1945.* New York: Rizzoli, 1990.

Harte, Bret. *The Wild West: Stories by Bret Harte,* with eight illustrations by Pierre Falké. Paris: Harrison of Paris, 1930.

Johnson, Ira D. *Glenway Wescott: The Paradox of Voice.* Port Washington, N.Y. and London: National University Publications, 1971.

Kahn, Sy M. *Glenway Wescott: A Critical and Biographical Study.* Ann Arbor, Mich.: University Microfilms, 1957.

Kirstein, Lincoln. *By With To and From: A Lincoln Kirstein Reader.* Edited by Nicholas Jenkins. New York: Farrar, Straus and Giroux, 1991.

———. *Mosaic: Memoirs.* New York: Farrar, Straus and Giroux, 1994.

———. *George Platt Lynes, Portraits 1931–1952.* Chicago: Art Institute of Chicago, 1960.

———. *The New York City Ballet: Photographs by Martha Swope and George Platt Lynes.* New York: Alfred A. Knopf, Inc., 1973.

Levy, Julien. *Memoir of an Art Gallery.* New York: G. P. Putnam, 1977.

Lynes, George Platt. *The New York City Ballet Photographs Taken by George Platt Lynes: 1935–1955.* New York: City Center of Music and Drama, 1957.

————. "Portraits by Lynes." *U.S. Camera* 4 (November 1941).

————. "Portraits Should Be Imaginative." *Minicam* 6 (February 1943).

Lynes, Russell. *Good Old Modern: An Intimate Portrait of the Museum of Modern Art.* New York: Scribner, 1981.

————. *The Daring Eye of George Platt Lynes.* Unpublished Manuscript, n.d.

Mann, Thomas. *A Sketch of My Life.* Paris: Harrison of Paris, 1930.

Marks, Robert W. "George Platt Lynes: Photographer of Fantasy." *Popular Photography* (December 1939).

Mérimée, Prosper. *Carmen and Letters from Spain,* with ten illustrations by Maurice Barraud, stencil-colored by Eugène Charpentier. Paris: Harrison of Paris, 1931.

"Monroe Wheeler: A Profile" Unsigned article. *Apollo* (June 1964): 110–114.

Morrin, Peter. "PAJAMA Game: The Photography Collection of Paul Cadmus." *Arts* 53 (December 1978): 118–119.

Newhall, Beaumont. *The History of Photography from 1839 to the Present,* revised and enlarged edition. New York: Museum of Modern Art, 1982.

————. *Focus: Memoirs of a Life in Photography.* Boston and Toronto: Little, Brown and Co., 1993.

Phillips, Christopher. "The Judgement Seat of Photography." *October* 22 (Fall 1982): 27–63.

Porter, Katherine Anne. *Hacienda.* Paris: Harrison of Paris, 1934.

Prokopoff, Stephen. *George Platt Lynes: Photographic Visions.* Boston: Institute of Contemporary Art, 1980.

Rice, Shelley. *The Male Nude: A Survey in Photography.* New York: Marcuse Pfeifer Gallery, 1978.

Rosco, Jerry. "Remembering Cocteau." *Sequoia,* 29, no.2 (1985): 54–60.

————. "An American Treasure: Glenway Wescott's *The Pilgrim Hawk.*" *Literary Review* 37, no. 2 (Winter 1988): 133–142.

————. "Glenway Wescott: The Poetic Career of a Novelist." *Chicago Review* 37, no. 1 (1990): 113–127.

Rueckert, William H. *Glenway Wescott.* New York: Twayne Publishers, 1965.

Shakespeare, William. *Venus and Adonis.* Paris: Harrison of Paris, 1930.

Steegmuller, Francis. *Cocteau: A Biography.* Boston and Toronto: Little, Brown and Co., 1970.

Steward, Samuel M. "George Platt Lynes: The Man." *Advocate* 332 (December 10, 1981): 22–23, 27.

Thomson, Virgil. *Virgil Thomson.* New York: Alfred A. Knopf, 1966.

Travis, David. *Photographs from the Julien Levy Collection, Starting with Atget.* Chicago: Art Institute of Chicago, 1977.

Tyler, Parker. *The Divine Comedy of Pavel Tchelitchew.* New York: Fleet Publishing Corp., 1967.

Weber, Nicholas Fox. *Patron Saints: Five Rebels Who Opened America to a New Art, 1928–1943.* New York: Alfred A. Knopf, 1992.

Wechsler, Jeffrey. *Surrealism and American Art: 1931–1947,* with collaboration and an introductory essay by Jack J. Spector. New Brunswick, N.J.: Rutgers University Art Gallery, 1976.

Weiermair, Peter. *George Platt Lynes.* Innsbruck: Allerheiligenpresse, 1982.

Weinberg, Jonathan. "Cruising with Paul Cadmus." *Art in America* 80, no. 11 (November 1992): 102–109.

Wescott, Glenway. *Continual Lessons: The Journals of Glenway Wescott.* Edited by Robert Phelps with Jerry Rosco. New York: Farrar, Straus and Giroux, 1990.

———. *The Grandmothers.* New York: Harper and Brothers Publishers, 1927.

———. *The Babe's Bed.* Paris: Harrison of Paris, 1930.

———. *Calendar of Saints for Unbelievers,* with illustrations by Pavel Tchelitchew. Paris: Harrison of Paris, 1932.

———. *Fifty Photographs by George Platt Lynes.* New York: Julien Levy Gallery, 1934.

———. Illustrations of Mythology." *U.S. Camera,* no. 2 (January–February 1939).

———. *The Pilgrim Hawk.* New York: Harper and Brothers Publishers, 1940.

———. *Apartment in Athens.* New York: Harper and Brothers Publishers, 1945.

———. *Images of Truth: Remembrances and Criticism.* New York: Ayer Company Publishers, 1962.

Woody, Jack. *George Platt Lynes: Photographs 1931–1955.* Pasadena, Ca.: Twelvetrees Press, 1980.

———. *George Platt Lynes: Ballet.* Pasadena, Ca.: Twelvetrees Press, 1985.

———. *George Platt Lynes: Portrait 1927–1955.* Santa Fe: Twin Palms Publishers, 1994.

Wynhausen, Elisabeth. "The Persuader: A Great Museum's Hidden Asset is Monroe Wheeler's Prodigious Charm." *Connoisseur* (October 1983): 108–113.

Sources

The Yale Collection of American Literature, Beinecke Rare Book and Manuscript Library, at Yale University is the most important repository for information on George Platt Lynes, Monroe Wheeler, and Glenway Wescott. Its collection of materials includes Wescott's manuscripts as well as the personal papers and correspondence of all three men. Unless otherwise indicated, unpublished letters and documents used for this volume can be found in the Yale Collection of American Literature, Beinecke Rare Book and Manuscript Library, Yale University.

Acknowledgments

The authors would like to extend their thanks to the following individuals whose support on this project is greatly appreciated: the late Russell Lynes, Mrs. Russell Lynes, Mr. and Mrs. Richard Wheeler, Mr. Jerry Rosco, Mr. William Chandlee, III, and Mr. Bernard Perlin, with whom discussions about the different personages in this album were most helpful. We also extend our thanks to Ms. Patricia Willis, The Yale Collection of American Literature, Beinecke Rare Book and Manuscript Library, Yale University; Mr. and Mrs. Kurt Richter and Messrs. Claude Boss and Hans Sowa, whose generosity sustained several weeks of writing; and Mr. Daniel Levine, who helped explain the different aspects of triangular relationships.

First Edition Published by Arena Editions
573 West San Francisco Street
Santa Fe, New Mexico 87501 USA
505.986.9132 telephone 505.986.9138 facsimile
www.arenaed.com

© Copyright Arena Editions, 1998

All rights reserved. No part of this book may be reproduced by any means, in any media, electronic or mechanical, including motion picture film, video, photocopy, recording or any other information storage and retrieval system, without permission in writing from Arena Editions.

Travel Album Photographs © Copyright Collection Anatole Pohorilenko, 1998.

"The Expatriate Years, 1925–1934," © Copyright Anatole Pohorilenko, 1998.
All rights reserved.

"The American Years, 1935–1943," © Copyright James Crump, 1998.
All rights reserved.

Book Design and Art Direction, Elsa Kendall
Typesetting, Angela Taormina
Editing, Jenifer Blakemore

Distribution by D.A.P./Distributed Art Publishers
155 Sixth Avenue, Second Floor
New York, NY 10013
212.627.1999 telephone 212.627.9484 facsimile

Printed by EBS, Verona - Italy

First Edition, 1998 ISBN 0-9657280-4-8